IMAGES
of America

LOST OGDEN

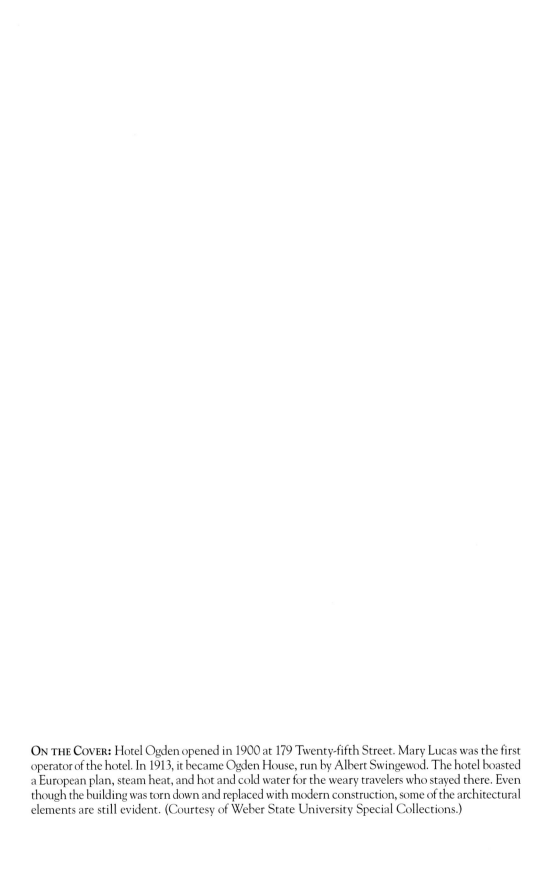

IMAGES
of America

LOST OGDEN

Sarah Langsdon and Melissa Johnson

ARCADIA
PUBLISHING

Copyright © 2015 by Sarah Langsdon and Melissa Johnson
ISBN 978-1-4671-3339-5

Published by Arcadia Publishing
Charleston, South Carolina

Printed in the United States of America

Library of Congress Control Number: 2014956911

For all general information, please contact Arcadia Publishing:
Telephone 843-853-2070
Fax 843-853-0044
E-mail sales@arcadiapublishing.com
For customer service and orders:
Toll-Free 1-888-313-2665

Visit us on the Internet at www.arcadiapublishing.com

To my family who supported me: Chamanpreet, Cade, and Sophie.
—Sarah Langsdon

To Jason, for putting up with me through it all.
—Melissa Johnson

CONTENTS

ACKNOWLEDGMENTS

Since the Special Collections Department was created at Weber State University's Stewart Library, it has sought to document the history of Ogden City and the surrounding counties. The materials housed within the department offer a myriad of stories and information about the community's history in manuscript collections, photographs, and printed sources. This book documents some of those stories through photographs. Unless noted, all the images we used are part of the collections at Weber State University. In particular, the Weber County Assessor's Office collection and the Richard Roberts and the John David Eccles photograph collections were utilized for their wonderful images.

We thank our contacts at Arcadia Publishing, Alyssa Jones and Matt Todd, who guided and prodded us through the process. We would also like to thank the staff in Special Collections who helped pick up the slack. University librarian Joan Hubbard supported this process from the beginning, and we offer her our appreciation. The 7,000-plus members of Remembering Riverdale/Ogden and Beyond were kind enough to share their memories. We must also thank the Hemingway Foundation for support in collecting the histories.

Several people have paved the way for this book through their research, writing, and enthusiasm for Ogden's history. First are Richard Roberts and Richard Sadler, who are responsible for the definitive histories on Ogden and Weber County. Next is Milton R. Hunter, who wrote the first history on Ogden under the direction of the Weber Chapter of the Daughters of Utah Pioneers. Finally, we express our gratitude to the Mountain West Digital Library and its growing archives of digital Ogden newspapers. Without that resource, and the microfilmed copies of the *Standard-Examiner* and other Ogden newspapers, no chronicler—past or present—could tell Ogden's story.

INTRODUCTION

It is early morning, and milkmen in starched, white uniforms begin their daily deliveries. The comforting scent of freshly baked bread from local bakeries wafts through the air as shopkeepers open their stores. Children hurry to school, shouting hellos to friends and racing for the playground. Traffic builds on the streets as buses pull out of the depot and shoppers jostle their way through department stores. Old men play checkers in the municipal park, while police officers walk their beats.

Down the street at Union Station, the chug and hiss of trains announces the arrival of hundreds of passengers. Their footsteps echo through the grand lobby as they rush up Twenty-fifth Street, hoping for a bit of refreshment after their long journey or looking for a quick shave from the corner barber. The bangs and clangs of laborers loading and unloading cargo on freight trains ring across the city, mingling with music from clubs and bars. As evening falls, finely dressed men and women go out dancing. Conductors give one last all-aboard call before their trains pull out of the station, a plaintive whistle echoing across the canyon.

Many of the sights and sounds of Ogden's yesterdays are no longer with us. Trains no longer stop at the Union Station, cowboys no longer unload their cattle at the massive stockyards, and many favorite restaurants and cafés have long since closed their doors. So why should we care about them anymore? Why do these memories pull at us so much?

Ours is not the first generation to look back at days gone by in this way. Ogden's story is one of continual change and reinvention. In 1915, John A. Boyle, an early settler, wrote down some of his memories in the *Ogden Standard Examiner* and described a town much changed: "I have seen Ogden grow from a muddy, straggling village to a beautiful city . . . I remember when there were not more than twelve houses on the bench and only two houses between Twenty-fourth and Twenty-fifth streets, on Washington avenue." He went on to write that Ogden was so changed from his youth that, "had it been pictured to [him, he] would have said, 'It is impossible.'"

Early pioneers like Boyle lived in a frontier town, working to tame the desert and build a thriving city. The year 1869 not only brought the transcontinental railroad, it also brought more capital, more industry, and more people. Homes and businesses spread in all directions, and streetcars were installed to whisk people through the city and up into the canyon. As Ogdenites grew in prosperity, their influence spread throughout the West.

Dance halls, movie theaters, and other forms of entertainment sprang up in the city. Governors, presidents, and other dignitaries were received in the city's best homes and assemblies. Schools, hospitals, and public works were built and improved. Ogden was truly thriving.

But struggle came again for Ogden, and for the entire country, as the Great Depression dawned. Despite a great deal of manufacturing and industry in the city's history, the community was still primarily agricultural, and Ogdenites were able to endure the economic hardships. As World War II broke out, several military installations were built in the area, bringing about another economic boom. Factories and farms gave way to homes in order to meet the housing demands of

a growing population, and Ogden again became a bustling city. Washington Boulevard between Twenty-second and Twenty-sixth Streets became a major shopping center, with several department stores lining it on both sides. Many people today still remember the downtown area brightly lit and decorated for the holidays as well-dressed shoppers moved from store to store and dined in local cafés.

All of this changed as passenger rail service declined. Just as the arrival of the railroad brought economic prosperity, its departure brought about a steady decline that Ogden struggled to overcome for many years. Historic buildings fell into disrepair, stores closed, and businesses left the city. But many of Ogden's citizens—remembering the city that once was—determined to breathe new life into the community. They began by restoring several important landmarks and putting them to use again: Peery's Egyptian Theater, the Union Station, and many of Twenty-fifth Street's storefronts. City leaders, business owners, and ordinary citizens continue to work together to revive Ogden and secure its future.

Perhaps this is why we feel the need to visit the past. Doing so reminds us of who we are and who we can be. We are able to understand our present, so as to better plan for the future. John Boyle understood this idea. After writing down his early memories of Ogden, he concluded, "I always had faith in Ogden and believed her future will be great. I believe her citizens the kindest and most enterprising in all the state, irrespective of party or creed. I think we should not be divided, but pull all together for the brightness and glory of Ogden."

In bringing together these images of lost Ogden, we have sought to explore these many cycles of growth, decay, and renewal. We owe a particular debt of gratitude to the Linda Love and her Remembering Ogden/Riverdale and Beyond Facebook page. The men and women who visit the site not only support the work we do in Special Collections, they also do the same work as they share their memories with one another. Because of them, and many others like them in the community, Ogden's stories will never truly be lost.

One

TWENTY-FIFTH, THE STREET THAT NEVER SLEPT

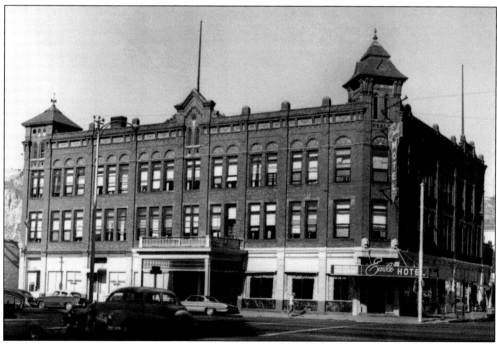

In 1900, Patrick Healy built the Healy Hotel on the corner of Twenty-fifth Street and Wall Avenue. The hotel was remodeled in 1912 to include more than 100 rooms. The Healy Hotel stood as the grand hotel that greeted weary travelers getting off the train until 1946. In October of that year, it was sold to the Earle hotel chain, and the name was changed to the Earle Hotel.

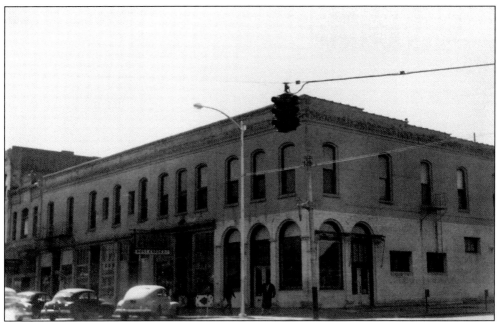

The Indian Curio Shop at 101 Twenty-fifth Street was owned by the Murphy family. Edward Murphy remembered of his grandfather's store, "You'd go into my grandfather's store and smell the peculiar odor of tanned buckskin. The people who ran the stores were people of character and personality that made them interesting."

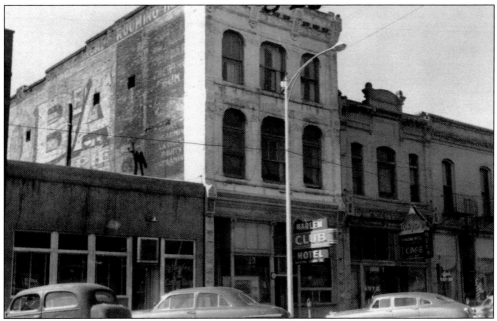

In 1950, Dora Williams opened the Harlem Club and Hotel at 115 Twenty-fifth Street to replace the White Front. The previous owner was denied a business license because he failed to bring the tavern up to sanitation and moral standards. Like many businesses on the street, the Harlem Club had its own gaming operations in the basement. In 1952, nine people were arrested for gaming charges at 3:00 a.m. for a poker game.

The site of 120 Twenty-fifth Street has always been associated with the Gift House. Abe Rubin first started off selling sandwiches and gifts. He soon moved into sporting goods and a pawnshop. Because of the proximity to the Union Station, he catered to the people getting off the train. The Gift House was one of the few places open to African Americans on the north side of the street.

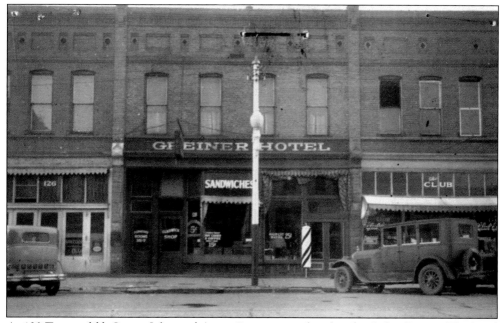

At 130 Twenty-fifth Street, John and Anna Greiner ran a hotel and café for 41 years. The hotel was originally called the Bismark, but Greiner renamed it after himself. John came to Utah from Germany in 1873. He spent most of his career as a chef for the Union Pacific dining car department. Anna passed away in 1933, and John lived until 1937.

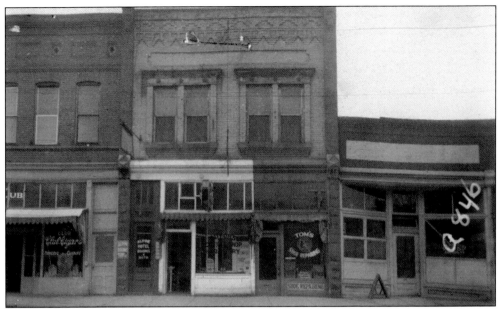

Twenty-fifth Street was known for providing all kinds of pleasures. Currently at 136 Twenty-fifth Street, Endless Indulgence brings its customers back to the 1950s with clothing and decor. Carrie Vondrus, owner of the store, talked about the building that used to be a hotel and brothel. She said that in the cribs upstairs, one can still see where the metal beds would scrape against the bricks.

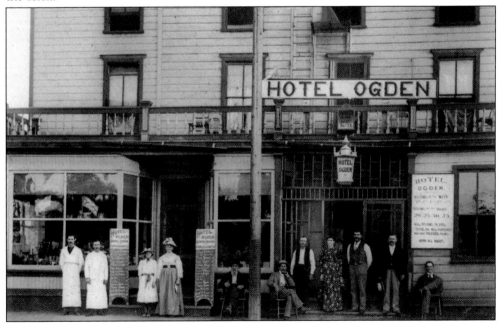

Hotel Ogden opened in 1900 at 179 Twenty-fifth Street. Mary Lucas was the first operator of the hotel. In 1913, it became Ogden House, run by Albert Swingewod. The hotel boasted a European plan, steam heat, and hot and cold water to the weary travelers that stayed there. Even though the building was torn down and replaced with modern construction, some of the architectural elements are still evident.

The Marion Hotel at 184 Twenty-fifth Street was financed by David Mattson in 1912. Mattson had the land on the corner of Twenty-fifth Street and Lincoln Avenue and received state money to help build the hotel on the lot. He ran for secretary of state of Utah. In 1925, the hotel was under new management. One of the many businesses that have occupied the corner store is Moore's Barber Shop, started by Willie Moore, who provided haircuts in Ogden for over 50 years.

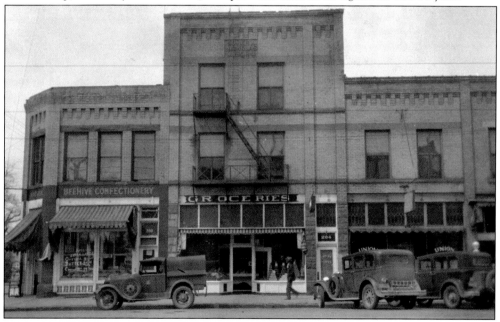

Gomer Nicholas opened the Gomer A. Nicholas grocery store in the property owned by his family at 204 Twenty-fifth Street. He was just six years old when his father died, and only twelve when his mother passed away. His uncle John Affleck stayed with the family and took care of the children. To honor his uncle, Nicholas donated the land for the John Affleck Ballpark in 1956.

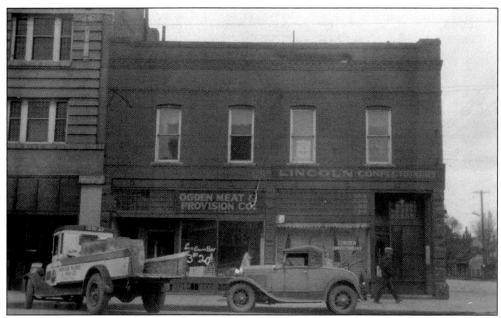

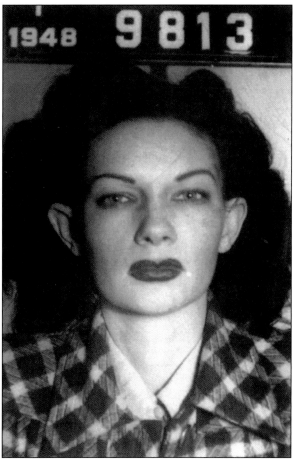

The site of 205 Twenty-fifth Street has best been known as the home of the Rose Rooms, a brothel run by Rosetta "Rose" and William Davie. Rose once said that she would rather the military men coming in the trains frequent her girls than bother the fine women of Ogden. The couple was arrested in 1950 for operation of a house of prostitution and served an 18-month sentence. Pictured at left is Rose Davie when she was arrested in 1950. After a long search, her mug shot was finally discovered in private hands. William Davie also owned Club Zebra and Bon Ami Club. Currently, the building houses the bar Alleged, which serves themed drinks based on Ogden's past.

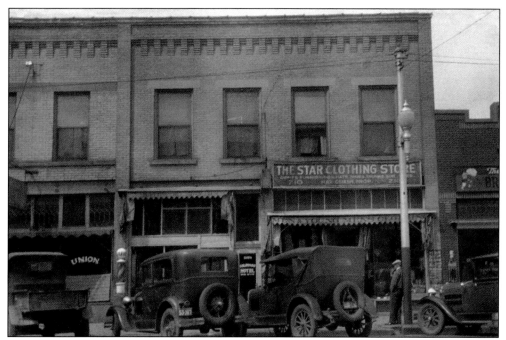

Marian and Max Oliash opened the Star Clothing Store at 210 Twenty-fifth Street in 1927. The business operated as a second-hand clothing establishment. In 1928, Max was arrested for operating a loan office in the store without a license. The store thrived until May 2, 1933, when a fire broke out and caused over $2,000 in damage. It never recovered, closing soon after.

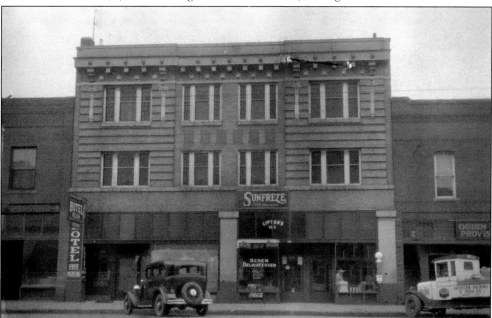

In 1911, David Maule completed the Helena Hotel at 213 Twenty-fifth Street, which he named after his hometown of Helena, Montana. Next door, Virgil Lucchesi operated the Ogden Deli that opened in 1933. He was arrested for liquor possession, having 28 gallons of wine and a few gallons of whiskey. The building today houses Smokey BBQ, with apartments on the top floors.

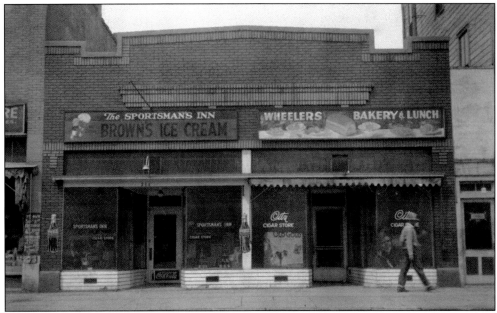

Wheeler's Bakery and Lunch opened at 216 Twenty-fifth Street. The restaurant offered low-cost lunches for the workingman until it closed in 1929. By 1956, the building had been turned into the Kokomo Club. The first owners were Frances and Lee Wann and Homer Metzgan. Leo Simone purchased it in 1961 and sold it to his son Ed in 1969. Ed and his wife, Cindy, have run the Kokomo ever since, providing a bar that is open to all.

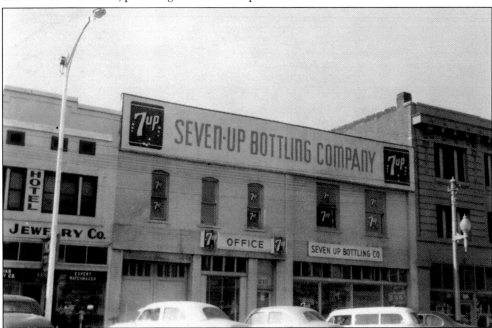

In 1947, Albert and Harold Scowcroft purchased the M&M Bottling Company at 217 Twenty-fifth Street. The Scowcrofts offered 7UP and other flavors under the M&M trade name. By 1972, Dorothy Scowcroft was president and general manager. She worked with soft drink manufacturers to contract with local bottlers.

N.O. Ogden Company opened shop at 236 Twenty-fifth Street. The store sold men's suits, shoes, and hole-proof hosiery. It offered high-class material, style, and workmanship at moderate prices. The store filed for bankruptcy in 1929. After that, Shorty's Eagle Clothing Company open in the same building. Until closing in 2015, Sock Monkey'N Around operated in the space, offering shoppers a chance to buy antiques.

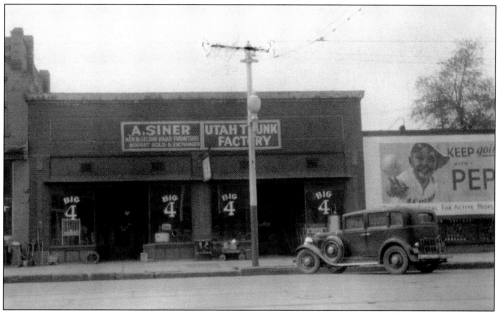

At 241 Twenty-fifth Street, Abraham Siner opened the Utah Trunk Factory in 1914. He offered first-class trunks and suitcases along with neatly done repairs. He was the president of Brith Sholem until he passed away in 1919. In the 1920s and 1930s, the store became Big 4, selling used furniture.

The building at 252 Twenty-fifth Street has a long, sordid history. It was used as the London Ice Cream Parlor in the early 1900s. This establishment served as the front for Belle London, one of Twenty-fifth Street's most famous madams. She ran the brothel on the upper floors until 1908, when she moved to Salt Lake City. The building still retains the ice-cream parlor sign.

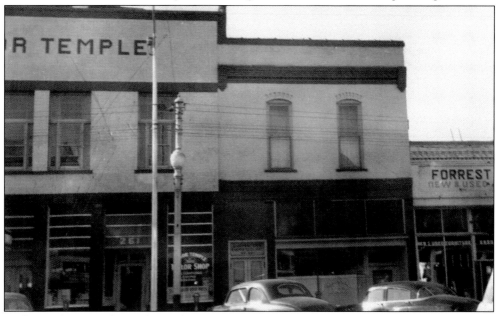

Ogden's Labor Temple was located at 259 Twenty-fifth Street. The temple was purchased and remodeled in 1943 by Local 206 of the International Hod Carriers, Building and Common Laborers' Union. It provided offices, lodge rooms, club rooms, and banquet and meeting facilities for Ogden trades union organizations. Following the war, the ranks of union membership in the Ogden area greatly increased. This increase led to the new temple.

At 127 Twenty-fifth Street, Billy
and Anna Belle Weakley opened
the Porters and Waiters Club. It
was one of the few places in Ogden
that catered to African Americans.
African Americans were segregated
to the south side of the street.
The club provided sleeping rooms
and food for not only the railroad
workers, but also for anyone coming
into town. The basement was
turned into a jazz club based on
the suggestion of Joe McQueen,
a musician who came into town.
The club brought in some of the
big names in jazz, including Dizzy
Gillespie and Count Basie. It was
open to people of all races who
wanted to hear great music.

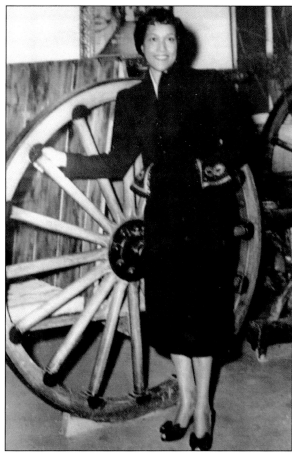

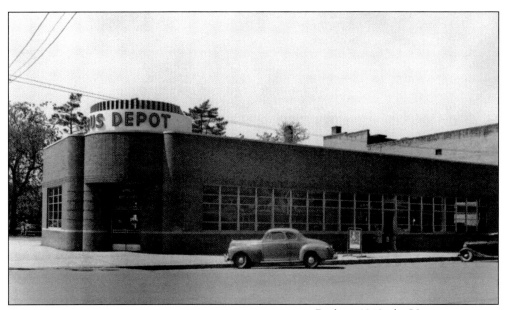

Built in 1940, the Union Bus Depot became a major transportation hub. Mike Nash, who worked in the depot's coffee shop, recalls the hustle and bustle at the station: "I remember one of the routes, the ticket agent would say, 'All aboard the north bound car. Loading in lane number two for Brigham City, Snowville, Strevelle, Burley, Twin Falls, Boise, Baker, Pendleton, Walla Walla, Lewiston, Spokane, Portland, Tacoma, Seattle, Vancouver.'"

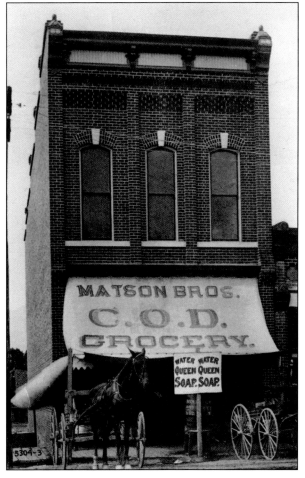

In 1889, George H. and W.E. Matson announced the opening of their new grocery store on what is now Twenty-fifth Street. The brothers advertised their "choice selection of fruits and vegetables," and a newly laid asphalt walk soon made it easier for customers to visit their store. The brothers also joined several other business ventures, including the Utah Canning Company.

Two

WASHINGTON BOULEVARD

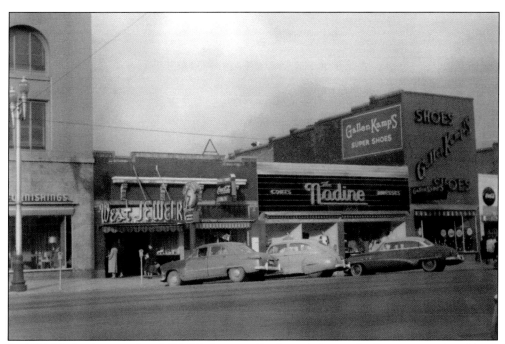

In 1931, Nadine's opened at 2330 Washington Boulevard. It was the best-equipped and best-stocked junior department store in the West. The store carried everything to clothe the woman. It was remodeled in 1938 to ease the shopping experience, and again in 1941 to add even more space and staff.

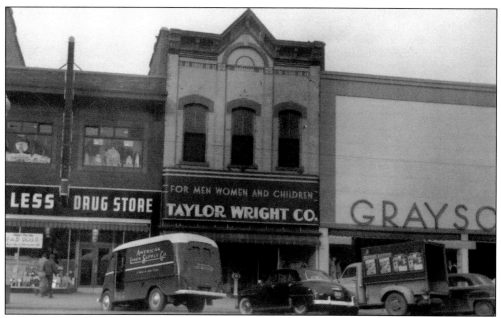

Downtown Ogden was a window-shopper's paradise during the 1920s to 1950s. People vividly remember the shops all decked out for Christmas and the wonderful store windows that were beautifully decorated. Grayson's Department store was known for its cheap but well-made clothing. It was also the first store in Ogden to have an escalator installed.

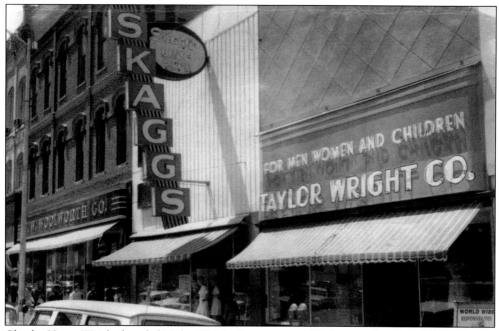

Charles Henry Wright founded Taylor Wright Company in 1917. Prior to that, he sold his interests in his family store, W.H. Wright, and bought the building at 2371 Washington Boulevard to start his own store. He named it Taylor Wright after his mother, Emma Taylor, who never received recognition for her part in W.H. Wright and for getting the six boys up and to work. The store offered men's, women's, and children's apparel and shoes.

Woolworth opened at 2373 Washington Boulevard in 1907. It covered 2,400 square feet and employed seven people. It was Ogden's most up-to-date, streamlined department store. By 1942, the store had expanded to five times the original size and had 56 employees. It offered 15,000 items. In 1961, a second store was opened at 3655 Wall Avenue.

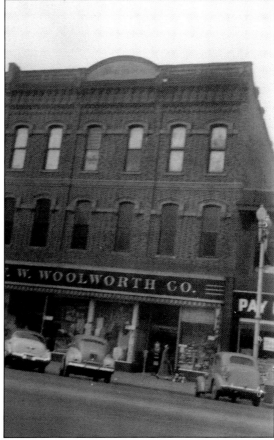

First National Bank was located at 2384 Washington Boulevard. Marriner Eccles served as director and president of the bank. Richard B. Porter was the vice president. In the bank building, Western Auto Supply opened at 2376 Washington Boulevard in 1923. The branch store was part of the largest auto-supply organization in the West.

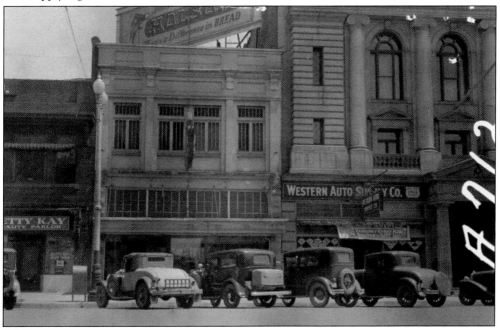

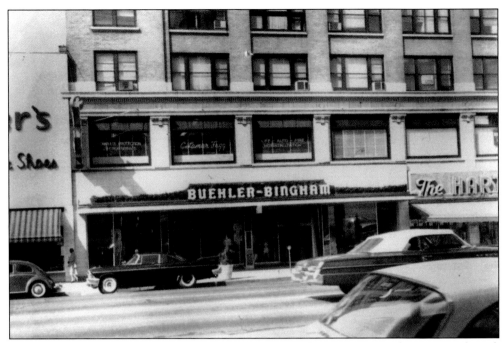

On December 8, 1947, R.H. Wagner opened Buehler-Bingham at 2407 Washington Boulevard. It was one of the largest and most beautiful men's stores in the Intermountain West. A quarter of the business was out of the stockroom because there was not enough floor space for all the stock. In 1953, the store was expanded to offer more men's and boy's apparel. Even during recession times, business at the store tripled.

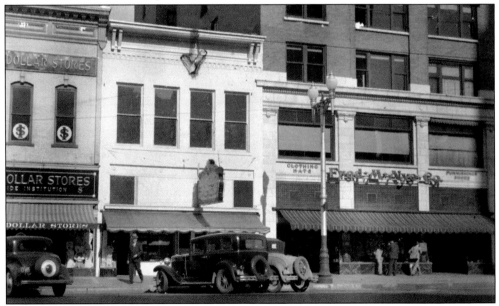

Fred M. Nye opened his clothing shop in 1898 at 2409 Washington Boulevard. The prestige of the institution with its ideals of service and its reputation for quality merchandise has never been diminished. In 1929, every employee donated $1 toward the campaign for a Greater Ogden advertising fund. The fund that was established showed the real spirit of Greater Ogden.

Atwell Frank Wolfer was born on December 17, 1880. He opened clothing stores in Denver and Cheyenne before coming to Ogden. He established Wolfer's at 2420 Washington Boulevard in 1916. He offered quality women's clothing, including suits, coats, and dresses. Atwell passed away on April 26, 1950. He was active in civic affairs and was a member of Ogden Chamber of Commerce.

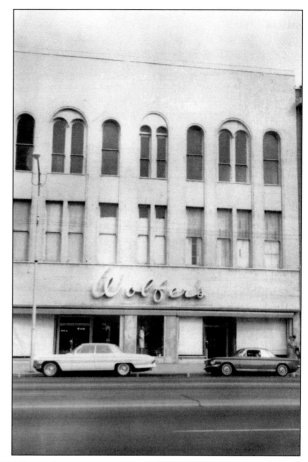

S.H. Kress & Co., a 5-10-25¢ store, opened in February 1927. The building at 2427 Washington Boulevard was constructed at a cost of $75,000. The first floor and basement housed the sales floors, with the second floor containing office space, the candy factory, and storage.

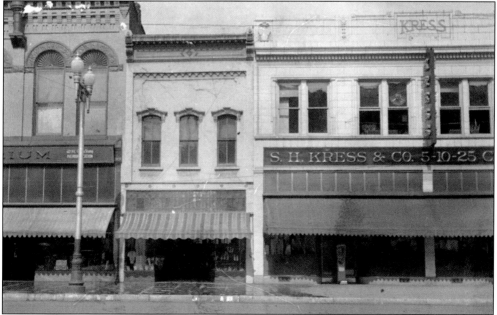

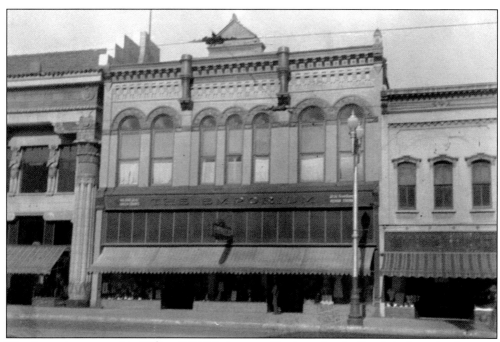

The Emporium opened in 1924 at 2431 Washington Boulevard and offered clothing, books, toys, and bedding. George M. Thorstensen acquired the business in 1933 and was still president of the store when he died in April 1950. Thorstensen was also president of Ogden Utah Knitting Company, which he started with his brother in 1905. Dora Coffman (below, left) served as the manager for the bookshop located within the Emporium. She worked there through the 1950s for Carl Wilson, who owned the books. She was also president of the American Association of University Women in Ogden in the early 1950s.

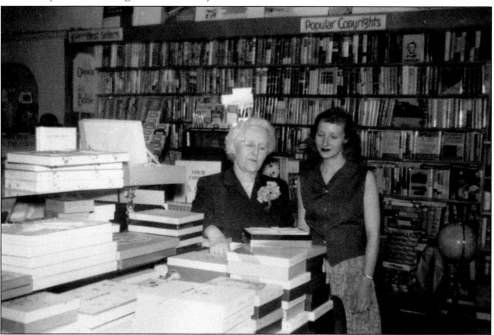

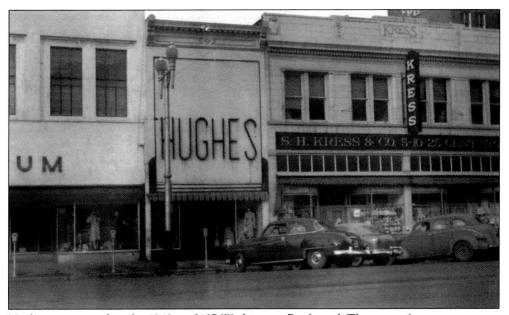

Hughes was opened in the 1940s at 2427 Washington Boulevard. The women's sportswear store sold dresses, coats, and suits. For its opening in 1944, the store advertised, "Our buyers have been searching the markets in preparation for this opening, so that you can be assured that every garment is the last word in fall fashions and at popular prices."

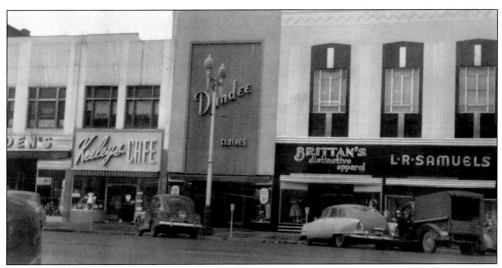

Located at 2463 Washington Boulevard, Keeley's Café was a popular dining spot known especially for its fish and chips, homemade candy, and malts. Opened in 1929 and managed by Joseph McCune, the restaurant operated for over four decades. McCune was also director of the Ogden Reds Baseball Club and treasurer of the Carnegie Free Library of Ogden for 17 years.

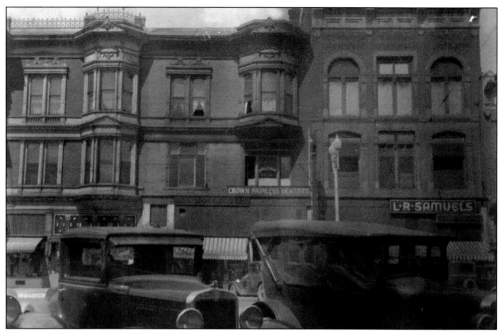

L.R. Samuels started business in Ogden in 1929 and moved to 2471 Washington Boulevard in 1935. The department store offered clothing for all family members, a restaurant, and a salon. In 1933, the rear of the store was remodeled to look like a circus for the amusement of the children. In 1968, Samuels merged with Auerbach's, a Salt Lake department store. By that time, L.R. Samuels had moved to New York but continued to run the store.

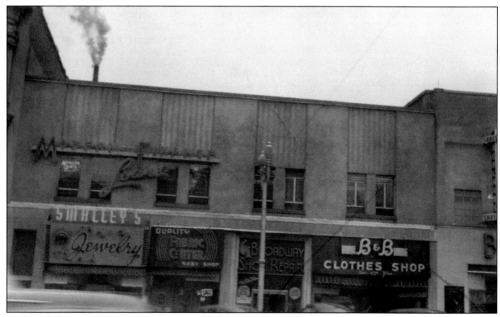

Smalley's Jewelers was one of Ogden's earliest jewelry stores, opening in 1897 on Kiesel Avenue. In 1940, the store had moved to 2479 Washington Boulevard, a more convenient location. Next door was the B & B Clothing shop at 2473 Washington Boulevard. Joseph Benowitz opened the store with his brother in 1907; it was one of the oldest active retail clothiers in the state.

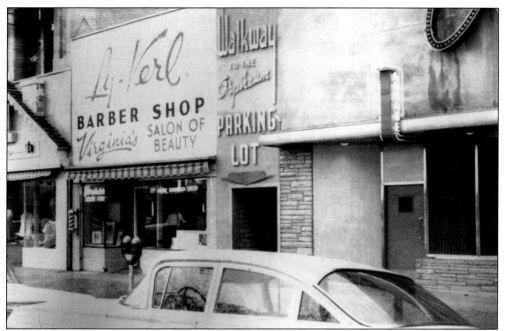

Many different businesses called 2528 Washington Boulevard home. In the early 1930s, George Pappas owned and operated the United Hatters and Shoe Shine before moving down the block. The Ly-Verl Barber Shop opened in May 1939 and employed four barbers, including Lyall Bishop, Ott Fuller, Verl Nicholls, and Lloyd Wold.

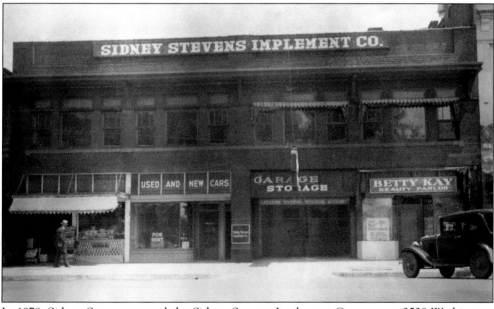

In 1878, Sidney Stevens opened the Sidney Stevens Implement Company at 2538 Washington Boulevard. The building was one of the first brick structures in Ogden. At one point, the store manufactured it own wagons and farm machinery, employing hundreds of people. The business also had a lumberyard and was the biggest in Utah at one time.

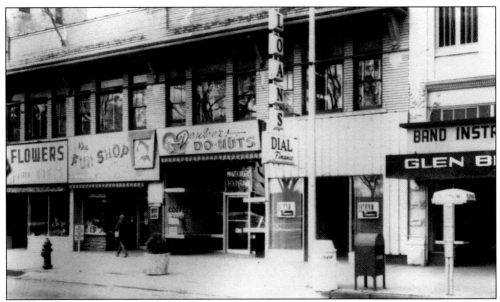

The corner of Twenty-fifth Street and Washington Boulevard was home to many different stores. In the early 1950s, the Fun Shop was located at 2536 Washington Boulevard and sold novelties to children. In 1961, Denkers' Donuts moved from Twenty-fifth Street to 2540 Washington Boulevard, with William and Leona Denkers offering lunches, breakfasts, and sandwiches. The store was closed in 1965 due to the owners' health.

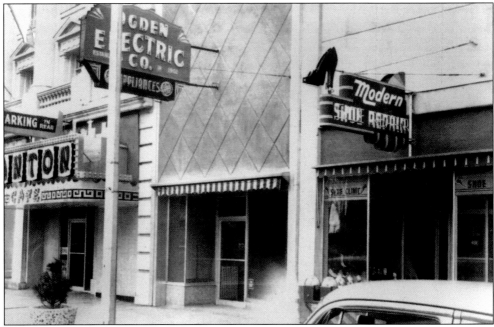

The Ogden Electric Company operated at 2556 Washington Boulevard. The business was Ogden's oldest and largest electrical contractor. Lawrence Herdti was the manager until he retired in 1959. Next door, at 2550 Washington Boulevard, was the Canton Café. The restaurant was known for its American and Chinese dinners. In 1952, the café was remodeled to include the new Peacock Room that hosted many banquets and events.

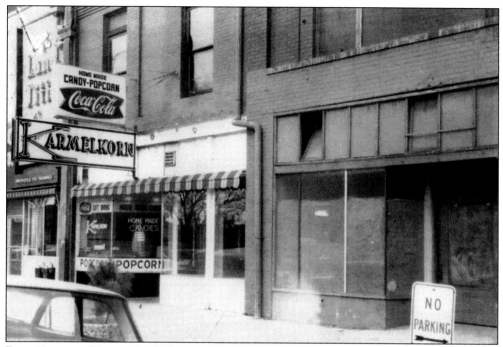

Doris Krauss and Bonnie Malcolm opened the Karmelkorn store at 2564 Washington Boulevard in 1948. The store was part of the Orpheum Theater block that provided entertainment to the people of Ogden. The ladies sold different flavors of popcorn, fudge, caramels, popcorn balls, and nut brittles. In 1959, it was sold to D.C. Oakley.

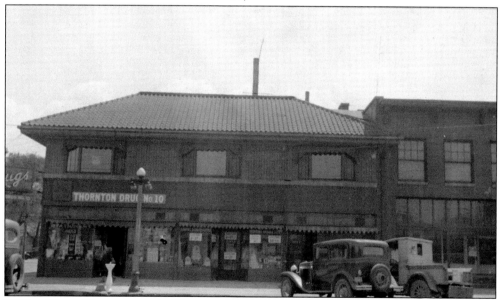

William Henry Thornton ran the Thornton Drug No. 10 at 2602 Washington Boulevard until 1936. In July 1936, it became the Broadstone Drug No. 2, owned by W.W. Stone and H.W. Broadbent. Vernon Rawson was in charge of the soda fountain. The store was remodeled to allow window-shoppers to view the entire store. In 1967, the building was purchased by Froerer Corporation, a real estate firm that had been in Ogden since 1914.

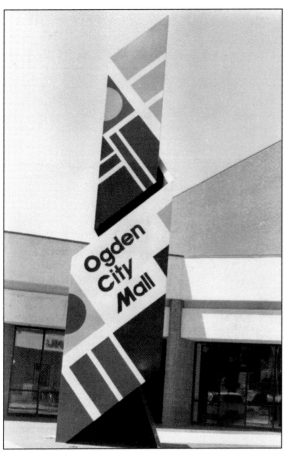

The Ogden City Mall opened in 1980 as a solution to the decline in shopping downtown. The anchor stores were J.C. Penney, Nordstrom, Bon Marché, and Zion Cooperative Mercantile Institution (ZCMI). In 1987, pop music darling Tiffany filmed the music video for "I Think We're Alone Now" at the Ogden City Mall. The colorful marquee can be seen featured in the video. The two-story mall was a popular shopping destination for Ogdenites through the 1990s. The loss of anchor stores such as Nordstrom and Weinstock's led to its rapid decline. The building was razed in 2003 to make room for the Junction entertainment complex.

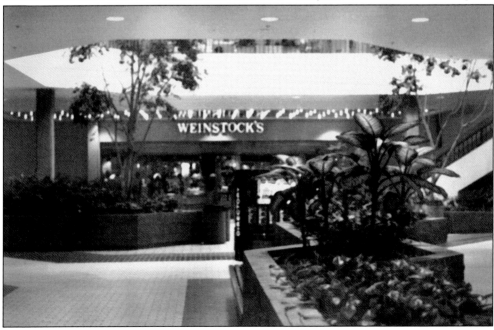

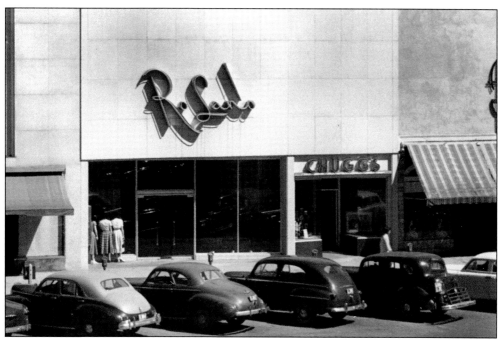

Opened in the mid-1940s by Carl Lancaster, RoLan's was later purchased by Dora Cross and Milt R. Fraser. Fraser was a businessman from San Francisco, but Cross had previously worked for RoLan's as a manager and in its credit department. After the store closed in 1956, Cross went on to manage Nadine's women's apparel.

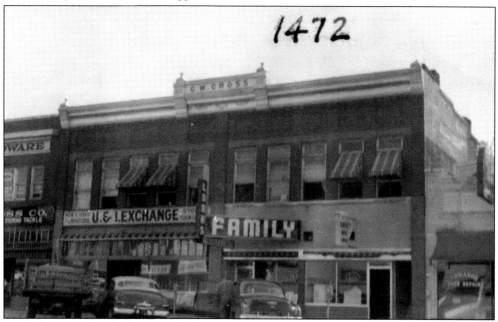

In 1883, C.W. Cross built Cross Western Wear at 2246 Washington Boulevard. He established a harness and saddle shop where leather goods were made, sold, and repaired. In 1916, the store moved next door; it operated there until 1971, when it moved back to the original building and offered western wear. The business was family run until it closed in 2005.

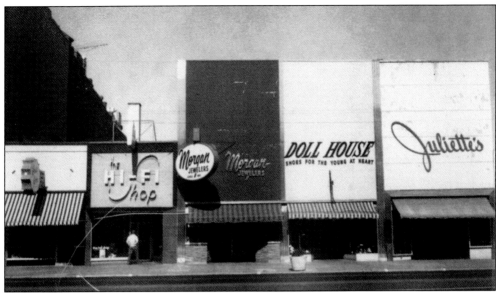

The Hi-Fi shop at 2323 Washington Boulevard became the site of one of Utah's most brutal crimes in 1974. On April 22, 1974, five people were taken hostage and tortured; only two survived, but with severe injuries. Even after such events, the stores still experienced brisk business. Two doors down was the Doll House, owned by Ralph Toponce, which provided women's shoes for the young at heart. The buildings were torn down when the Ogden City Mall was built.

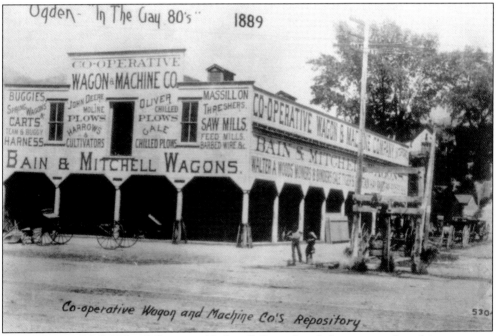

In 1884, Grant Odell, Heber J. Grant, and Joshua F. Grant founded a wagon and machine company called Grant, Odell & Company. Within a few years, their company merged with other, similar businesses to form the Cooperative Wagon and Machine Company. In 1902, the company was part of another merger, leading to another name change. Consolidated Wagon and Machine Company operated at Twenty-second Street and Washington Boulevard for 40 years.

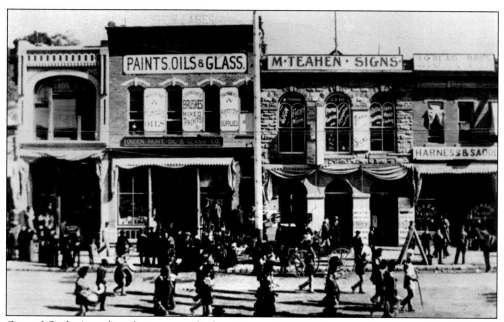

One of Ogden's earliest businesses, Ogden Paints, Oil & Glass, was incorporated in February 1889 by John Houtz and partners, who quickly moved into this building at Twenty-fourth Street and Washington Boulevard. In 1929, Ogden Paints, Oil, & Glass merged with Ogden Gasoline & Oil and Utah Oil Refining.

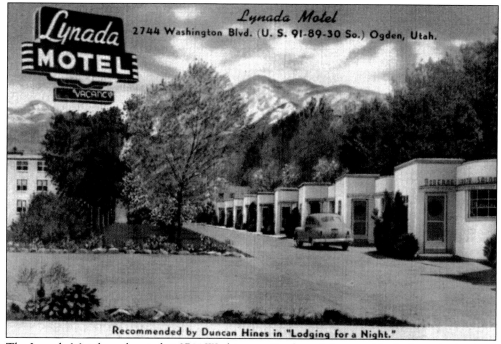

The Lynada Motel was located at 2744 Washington Boulevard, just two blocks from the business district and city hall. The motel offered 21 fully carpeted rooms with kitchenettes. Each room had an attached garage. In an edition of the brochure *Lodging for a Night* published in the mid-1950s, the motel is even recommended by Duncan Hines.

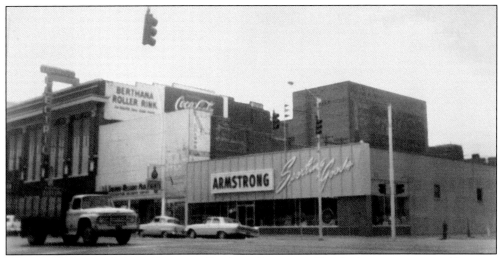

After working as a clerk for Browning Brothers Company, Claude Armstrong opened his own sporting goods store in 1919. Originally, the store was on Twenty-fifth Street, but it moved in 1964 to this location on Twenty-fourth Street. After more than 50 years in Ogden, Armstrong Sporting Goods closed its doors in 1971.

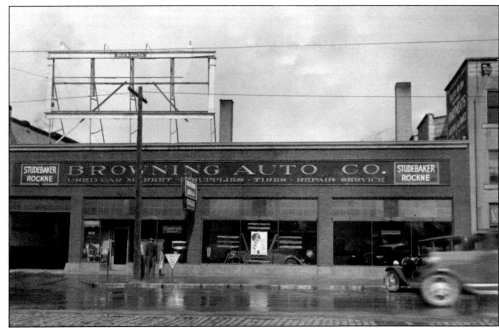

In 1925, Browning Auto Company moved from 2450 Grant Avenue to 2626 Washington Boulevard. Frank Milton Browning was the owner and operator of the car shop. He was agent for Willys-Knight and Overland cars. He developed Chevrolet agencies in Utah and Idaho and was instrumental in acquiring the land needed to build Ogden Arsenal, Hill Field, and Utah General Depot.

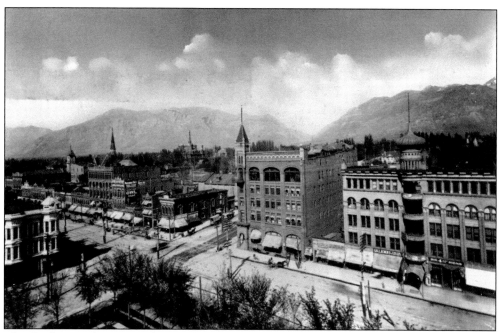

The Orpheum Theater was known for the vaudeville and stage plays that would occur on the stage at 2520 Washington Boulevard. The stage performers included the Marx Brothers, Jenny Lind, and Burns and Allen. Movies replaced the plays in the 1940s, and the Orpheum operated as a cinema until 1982. After that time, the building was run down and in need of repair. The Turkish minaret had been demolished in years previous. The structure was demolished in 1983 to provide parking for the renovated Ben Lomond Hotel. The Ben Lomond Hotel had stood next to the Orpheum since the 1890s, first as the Reed Hotel, and then, in 1927, as the Bigelow.

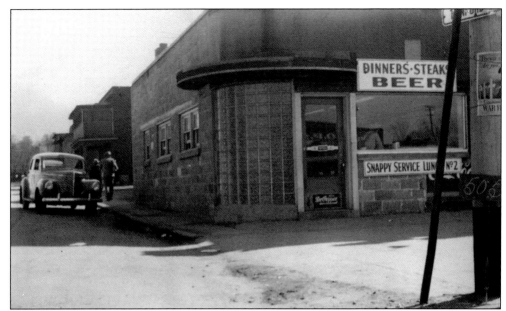

Carl M. and Willis E. Lancaster were the owners and operators of the Snappy Service lunch stands. The first one opened in 1928 at 2233 Washington Boulevard. The next shop to open was at 2260 Washington Boulevard. The stand offered quick lunches and drinks for the workingman. By 1938, the brothers had opened five shops, including ones in Provo and Logan. The slogan of the chain was "the farther you get from one shop, the closer you get to another."

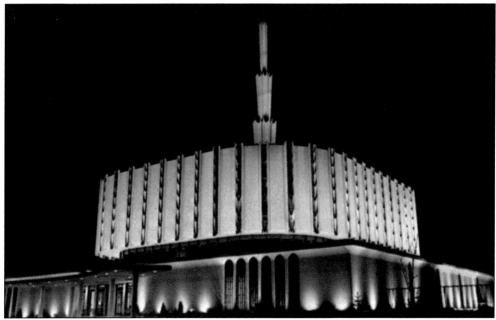

In 1967, the Church of Jesus Christ of Latter-day Saints announced that it would build a temple on Washington Boulevard between Twenty-second and Twenty-third Streets. The temple was completed and dedicated in 1971. In 2011, renovations began on the temple, reshaping the exterior and moving the entrance. As part of the renovation, the historic Daughters of Utah Pioneers museum was moved from the temple grounds one block west. The temple was reopened in 2014.

Three

IMMIGRANTS AT THE CROSSROADS

George Vetas came to Ogden in 1916 with his brother from Greece. They started a confectionary business at Twenty-eighth Street and Washington Boulevard. Later, George moved to Five Points and started a café at 215 Washington Boulevard. He was a charter member of the Order of AHEPA (American Hellenic Educational Progressive Association) and a member of the Greek Orthodox Church. He passed away in June 1944.

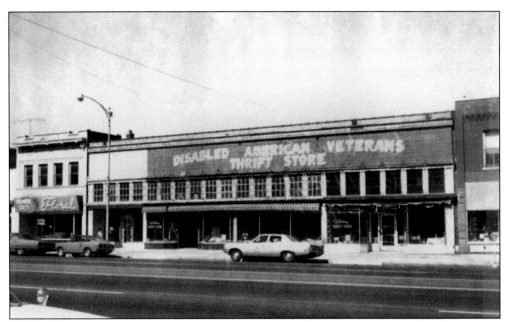

At 2211 Washington Boulevard, Ephraim Van Dyke opened Van Dyke's Sanitary Food. Beginning in 1929, he operated the store and even offered delivery for any orders over $2.50. By 1932, he sold his interests in the store to C.S. Dawson. Van Dyke continued to own a dairy herd and provide local dairy products to the store.

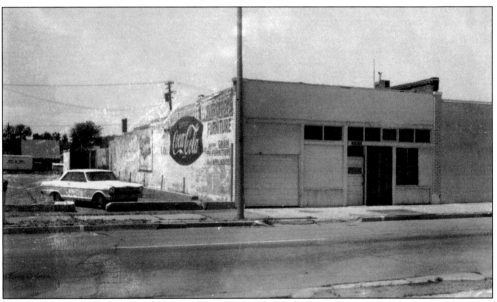

James Bubolis owned the Commercial Poultry and Egg shop at 2233 Kiesel Avenue. The store moved from 1717 Washington Boulevard in 1936 to provide better and prompter service. Bubolis offered fresh chicken that was killed and cleaned while customers waited. The store also had plenty of fresh eggs. Originally from Greece, Bubolis stayed active in local Greek organizations until his death in 1937.

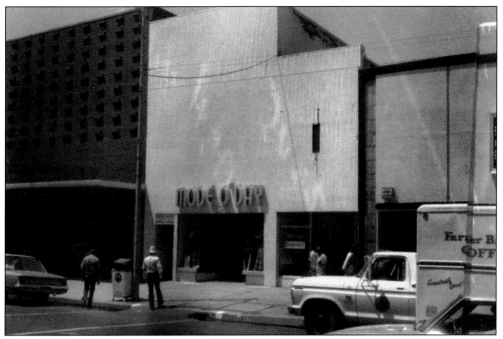

In May 1917, Gus G. Mahas opened the Los Angeles Fruit Store at 2245 Washington Boulevard. The store offered a full line of fruits, candies, and groceries. In 1926, Mahas was arrested for selling liquor from the shop. His cousin Gust A. Mahas owned the Ben Lomond Fruit Store farther north.

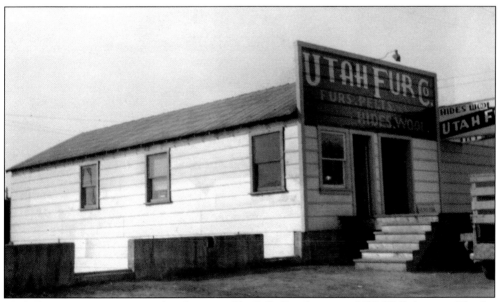

Utah Fur Company was owned and operated by Billy Zondervan at 2270 Wall Avenue. The fur company dealt with deer hides, pelts, and even muskrats. Even in 1959, the fur trade was still active in Ogden, and locals still hunted muskrats, beaver, wildcats, and coyotes. The hides were given to the Utah Fur Company for drying.

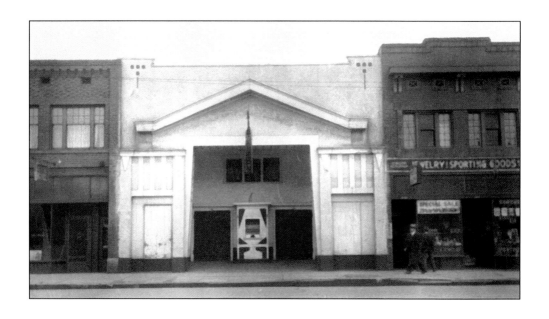

This building at 225 Twenty-fifth Street was erected in 1912 and housed a live-action theater. In 1931, it became the Weber Theater. The object of the theater was to give opportunities to developing talent and to present the public the best in drama at moderate prices. Bertha Eccles Wright was the manager and director of the theater. In 1948, the building was sold to the Ryjuin family, who turned it into a Chinese restaurant, the Star Noodle Parlor. The restaurant was known for its noodles and for the neon dragon sign that hung out front. Missing since 2008, the sign was restored and placed back on the building in January 2015.

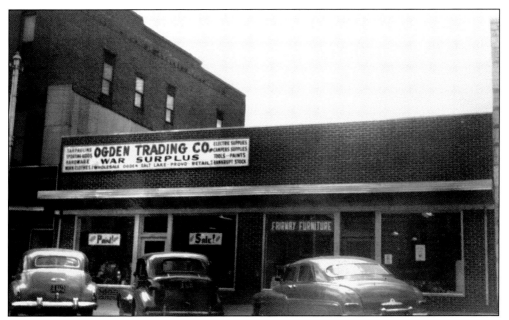

Ogden Trading Company opened in 1949 at 273 Twenty-fourth Street. It was formerly War Surplus Company. The trading company sold blankets, shoes, and Navy undress and dress jumpers that were restyled for civilian wear. The store claimed to sell anything in the store at the customer's price. By the late 1940s, it offered clothing, appliances, socks, shoes, records, and paint.

Sam Wong was the owner of the Grand Cafe at 274 Twenty-fifth Street. On March 2, 1952, the 60-year-old owner was severely beaten by a robber who stole $500. The attacker hit him from behind so that Wong was never able to identify him. Wong suffered a broken nose and multiple head injuries. Examples like this show the rough side of downtown Ogden during the 1950s.

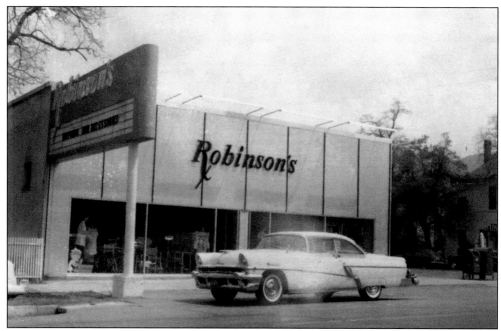

Gerard Klomp was an immigrant from Holland. In 1917, he took over Scriven Grocery and turned it to Jerry's Grocery at 584 Twenty-fourth Street. He was president of the Ogden Retail Grocer's Association and active on the Ogden School Board. During World War II, he urged citizens to not make a run on foodstuffs. Klomp was even knighted by Queen Juliana of Holland in 1961. He operated the store until 1958. The business became Robinson's in 1961.

John Bockas opened a sweets and lunch shop at 406 Twenty-fifth Street in 1930. By 1940, his business had expanded, and he opened John's Sweet Shop at 965 Twenty-eighth Street. In the shop, he made his own candies. He was known for the English toffee, the Yankee mix of hard candies, and the Yuletide mix of chocolates and bonbons.

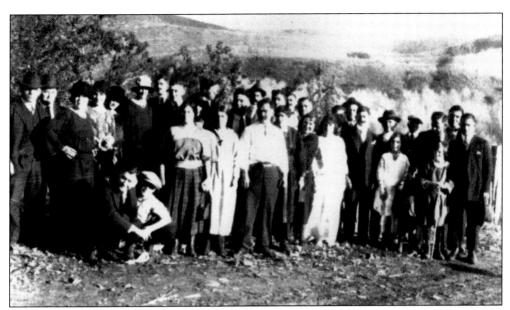

John Thiros came to Ogden at the age of 22 in 1907 from his hometown in Greece. He married Christina Hirakis, and they are pictured here on their wedding day in Huntsville, Utah, in 1923. He operated a sheep ranch and farm up in Huntsville from 1917 to 1941 before working for Hill Air Force Base.

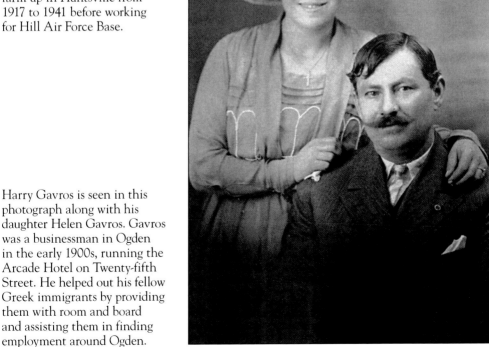

Harry Gavros is seen in this photograph along with his daughter Helen Gavros. Gavros was a businessman in Ogden in the early 1900s, running the Arcade Hotel on Twenty-fifth Street. He helped out his fellow Greek immigrants by providing them with room and board and assisting them in finding employment around Ogden.

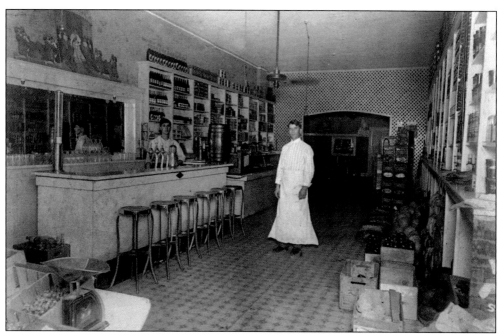

Tom Liapis was born November 27, 1886, in Greece. He arrived in the United States in 1907 and began working for the Union Pacific Railroad. In 1916, he moved his family to Ogden, where the family owned a small farm at Fourteenth Street and Grant Avenue. At left, he is pictured with his wife, Rachel. Liapis bought the Washington Fruit Store at 2319 Washington Boulevard, pictured above, which he ran for many years. The store was open seven days a week until it was lost in the Great Depression. He often gave away merchandise and loaned money that was never repaid. Many friends remember his generosity with candy, ice cream, and fruit from the store. Seldom did anyone leave his farm without cherries, peaches, or grapes.

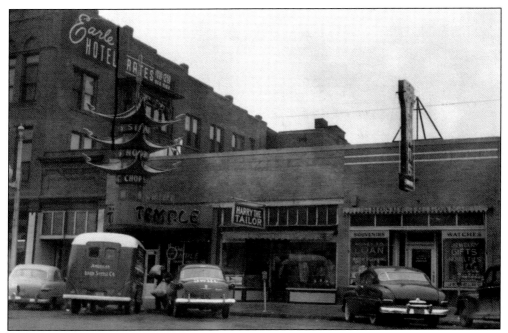

The China Temple opened in January 1961 at the site of the China Pagoda at 120 Twenty-fifth Street. The restaurant offered Chinese and American food. With the rise of civil rights activism, on April 11, 1962, three African American airmen from Hill Air Force Base protested with a sit-in. Milton Farr, Cecil Williams, and Lencis O'Brien were refused service and told to leave before the police were called. They were told to go across the street to be served.

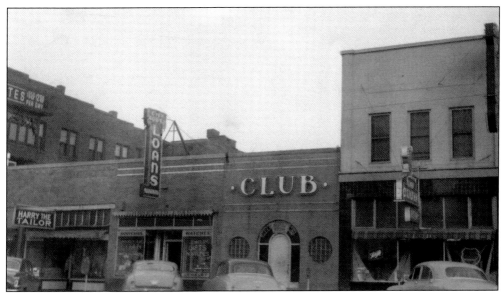

On Twenty-fifth Street near the Union Depot, Harry the tailor owned a shop next to the China Temple and the Club. He was one of the many Jewish merchants in Ogden. His shop was just a block away from the depot, and anybody who came from that direction could stop in to have a pair of pants shortened or lengthened or to buy a jacket.

In 1901, Harry Gavros immigrated to Ogden from Greece. He opened the Gavros Hotel Café and Bakery. By 1930, he became a grocer by opening Gavros Confectionary and Grocery at 148 Twenty-sixth Street. In 1936, he was arrested for selling a loaf of bread on a Sunday, which violated local blue law. Mayor Harman Peery was supportive of Gavros as he felt the ordinance was hurting local businesses.

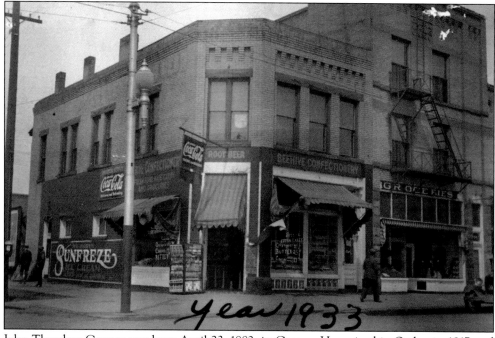

John Theodore Cosmos was born April 23, 1882, in Greece. He arrived in Ogden in 1917 and opened Beehive Confectionery at 200 Twenty-fifth Street. He was known for his handmade chocolates. Cosmos was an active member of the Greek Orthodox community and AHEPA society until his death in July 1941. The building currently houses Lucky Slice Pizza.

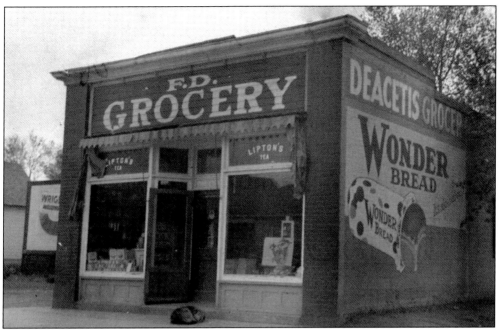

Many of the immigrants in Ogden opened profitable businesses. In 1929, Frank Deacetis, born in Italy in 1882, opened Deacetis Grocery at 2811 Lincoln Avenue. He ran the store until 1941, when he sold it and it became the Lincoln Market. In April 1955, Deacetis became an American citizen, which he claimed proudly until his death in 1972.

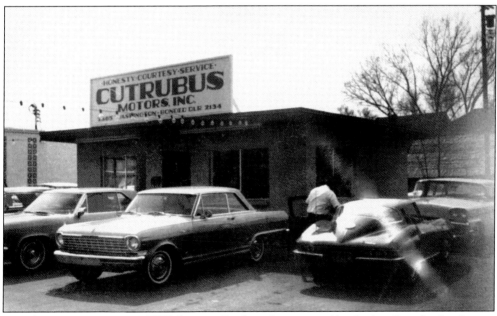

Cutrubus Motors, Inc., at 2865 Washington Boulevard, was owned by the four Cutrubus brothers— Jim, Dan, Phida, and Homer. The brothers learned about business from their father, Gus J. Cutrubus, who was the founder of the Utah Cigar Company that opened in 1911. He worked until he retired in 1961. The Cutrubus family has been active in the Greek War Relief and AHEPA.

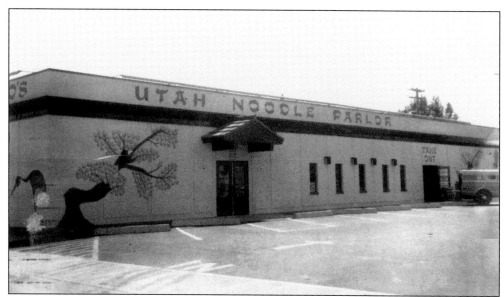

Utah Noodle Parlor was opened by George Uno in 1937 at 2430 Grant Avenue. Uno was the president of the Showa Club of Ogden, which provided education, social activities, and athletics to American-born men of Japanese descent. In 1940, Sam Matsumura took over the restaurant. In the 1970s, Leo and Mamiyo Iseki moved the restaurant to 3019 Washington Boulevard. Utah Noodle Parlor was best known for its butterfly shrimp and pork noodles.

Ernie Durbano opened Paisanos at 3050 Grant Avenue. The restaurant was known for its steaks and fine Italian foods. Durbano banded with many other restaurant owners to have the city take away the brown-bag alcohol rule. They wanted to allow people to purchase drinks at their establishments. Durbano sold the restaurant to Nick Biblis in 1972.

Four

DOWNTOWN OGDEN

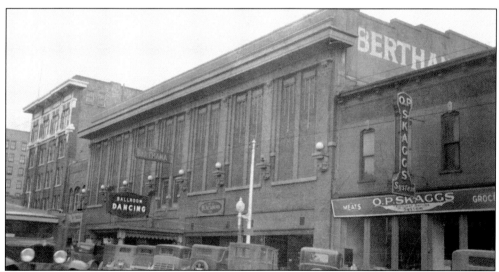

Built in 1914 by Annie Taylor Dee and Bertha Eccles, the Berthana was a social and cultural center for Ogden. The ballroom officially opened May 26, 1915, with Gov. William Spry and his wife, the former Mary Alice Wrathall, in attendance. Designed by Eber F. Piers, the building not only included the ballroom with orchestra platform, but also a ladies' parlor, men's smoking room, and a banquet room.

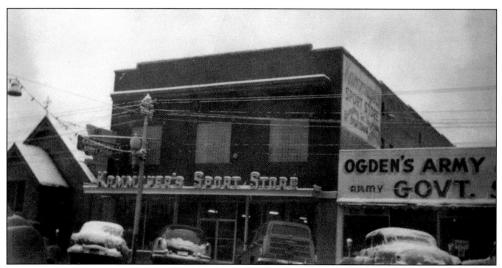

In 1922, Harry Kammeyer opened a bicycle-repair shop on Kiesel Avenue, later bringing his two brothers, Edward and Ernest, into the business with him. The three brothers worked together very well, and soon they expanded the business to sell bicycles and other sporting goods. In 1933, they moved their sporting goods store to this location on Twenty-fourth Street. It remained in business until the 1970s.

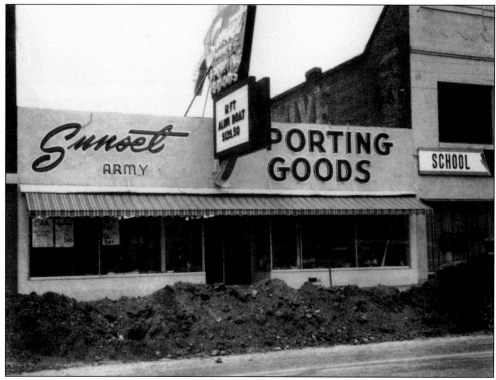

Several businesses have operated at this location, but an Army surplus store opened in 1944 with Julius Garfield as manager. In May 1964, the store was extensively remodeled, adding 3,000 square feet of space; later that fall, it was renamed Sunset Army Sporting Goods, with a sister store taking the same name on Highway 89. The business closed in the 1970s.

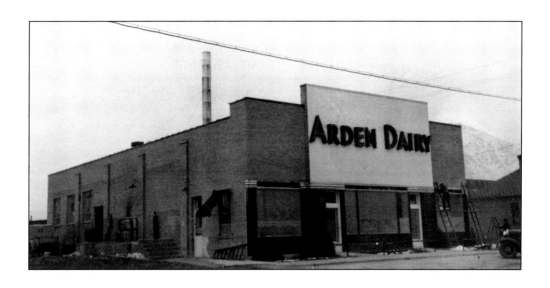

The dairy industry has long been an important part of Ogden's history, and several small dairies operated for decades. Part of the Mid-Western Dairy Products company, Arden Dairy first came to Ogden in 1933 on Grant Avenue. Within a few years, the creamery had moved to 340 Twenty-first Street, where it remained until 1970. Famous for its Sunfreze ice cream, Arden Dairy eventually became a part of Meadow Gold Dairy. Ekins Dairy was founded by Ernest Ekins and his wife, Arvilla, in the 1930s. Their dairy farm was located on Twenty-fifth Street until the 1960s, when it merged with another dairy and moved operations to Roy.

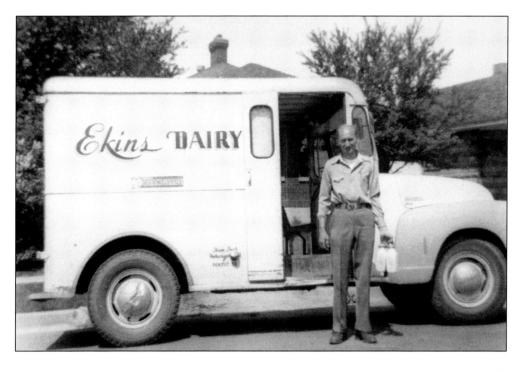

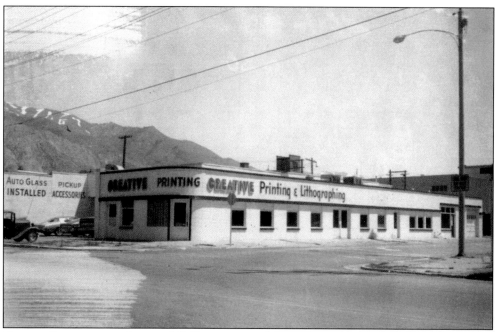

Creative Printing, seen here at 361 Twenty-second Street, was just one of the many printing companies that were established in Ogden. The building was torn down in the 1960s to make way for the LDS Ogden Temple. During the 1930s and 1940s, the company was active in the Ogden Independent League that pitted basketball teams from various companies against each other. It also provided supplies to Weber County Schools and for the city elections in Ogden.

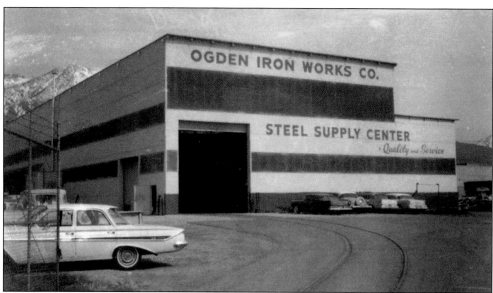

James W. Silver founded Ogden Iron Works in 1916. The plant, located at 185 Twenty-third Street, was one of the first ironworks and steel-fabricating plants in Utah. The family-run business manufactured industrial equipment, including mine cars and portable beet piler convoying machinery. The factory was operational until 1993.

54

The Mutual Creamery Company, incorporated in 1915, was an amalgamation of dairy farmers and dairy-selling agencies in 11 states. This unique arrangement was the brainchild of W.F. Jensen, who opened his first dairies in the early 1900s, including the one pictured here. Mutual Creamery became known for its Maid O'Clover butter, named by Jessie Holley, whose winning entry was one of 7,000.

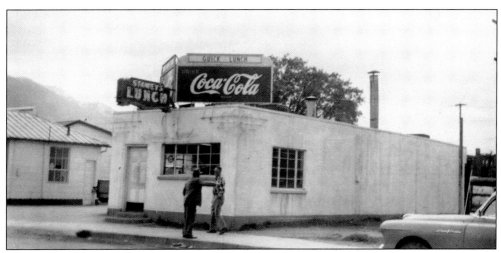

Originally, Edward C. Stamey opened his café, Stamey's Lunch, in 1946 on Twenty-fifth Street, but he soon moved to this location on Twenty-fourth Street. In addition to running his café, Stamey was a member of the chamber of commerce and was the Weber County representative for the Utah Restaurant Owner's Association. Although he only stayed at this location for a few years, he continued to run restaurants for several years.

First opened in 1913 by Emma Bingham, La Grande Cottage Hotel was later taken over by Domingo and Maria Asuncion Ydo. Both were Basque natives of Spain and came to Ogden in 1923. The hotel served as headquarters for sheepmen bringing their herds to the stockyards, but it was also known for its moonshine during Prohibition. Domingo died from an accidental gunshot wound in 1939, and Maria remarried a few years later.

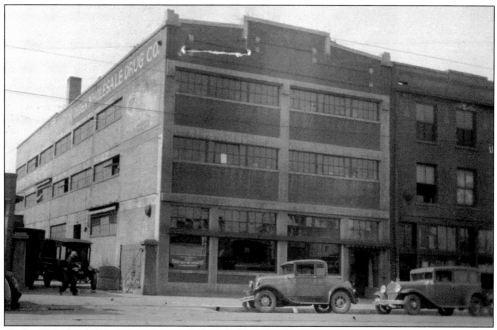

Ogden Wholesale Drug Company was founded by Charles B. Empey in 1904. Empey had his start at the William Driver and Son Company at the age of 12. In 1903, he married his wife, Katie, and they went on to have three children. In 1929, Empey sold his business, but he continued as company president until his retirement in 1947. Known as one of Ogden's most prominent businessmen, he died in 1961.

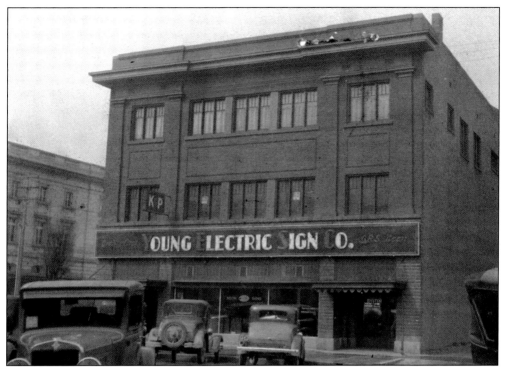

The Young Electric Sign Company was founded in 1920 by Thomas Young, an English immigrant who came to Utah in 1910. Although the company, now known as YESCO, has designed signs in Las Vegas, New York, and London, locals will best remember it for its work on the Star Noodle Parlor neon dragon on Twenty-fifth Street.

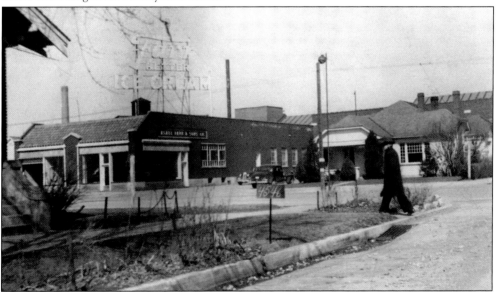

Farr's Ice Cream, Ogden's oldest ice-cream shop, originally began in 1895 as an ice-harvesting business. As modern refrigeration developed, however, the Farr family decided to make the switch to ice cream. In its long history, Farr's Ice Cream has developed more than 600 flavors, but black licorice is often mentioned as a local favorite.

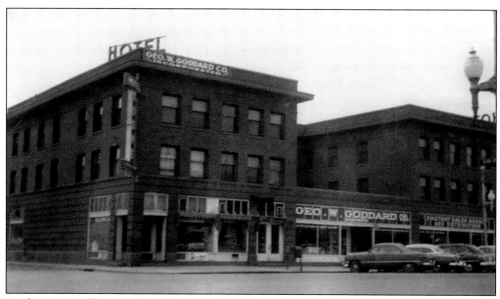

At the corner of Twenty-fourth Street and Wall Avenue stands the George Goddard Building. The company offered industrial and institutional equipment and supplies. In 1969, Harold Stites purchased the company from the Goddard family. Housed in the same building was the Toone Hotel. George Toone was active in community service, such as providing space for the Kris Kringle Korporals Christmas Program. The building was designated as Ogden's first public fallout shelter in 1962.

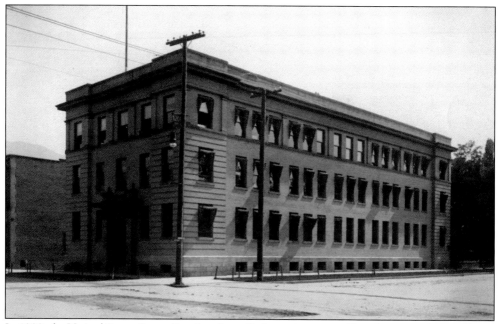

In 1908, the United States Forest Service chose Ogden as its regional headquarters. Originally, its offices were in the First National Bank building, but in 1909, this new facility on Twenty-fourth Street and Lincoln Avenue was constructed. Forest Service offices remained here until 1934, when the building was handed over to the Emergency Relief Fund and another Forest Service building was erected at Twenty-fifth Street and Adams Avenue.

The Sakurada Fish Company was opened at 259 Twenty-fourth Street. Toki and John Sakurada moved to Ogden in 1919, and the store was in operation from 1920 to 1959. It sold everything from fresh oysters to canned fish. The mottoes of the store were "From the World's Best Markets" and "Ocean Floor to your Door." John Sakurada passed away in 1959, but his legacy lived on when Masuko Ryujin opened the Star Noodle Parlor on Twenty-fifth Street.

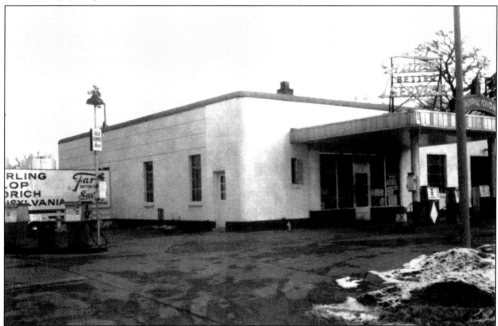

In 1936, Vern and Asael Farr Jr. opened Farr Better Service station at 302 Twenty-first Street. The service station offered gas, lubricants, and tires. Its slogan was "Over at Farr's Better Service at Twenty-first Street and Grant Avenue, they grease a car with all the thoroughness of a mother washing her small son's ears. And that's mighty thorough if you'll remember."

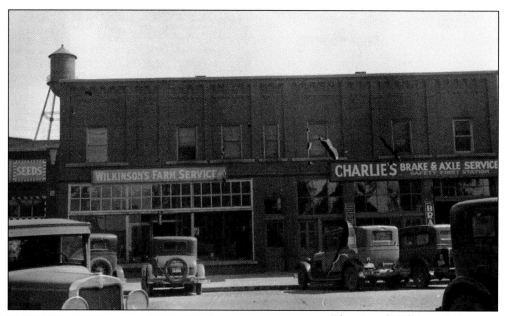

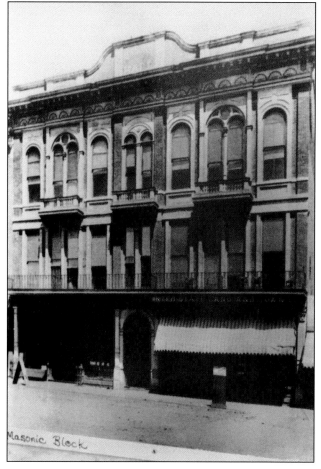

Masonic Block

The aim of Wilkinson's Farm Service Company, located at 359 Twenty-third Street since 1928, was to help the local farmer. The store offered service with factory-standard methods plus genuine parts. During the 1930s, Wilkinson's put more tractors on farms in Weber County than any other implement dealer. S.C. Wilkinson served as president and general manager, with Edmond Arave serving as vice president and George Wilkinson serving as secretary treasurer.

Ogden's Masons first met in the 1880s on the third floor of William Driver's drugstore building and remained there for about a decade. The group used this structure on Washington Boulevard until 1905, when it moved into a new building at 2550 Washington Boulevard. This new edifice was designed by Leslie Hodgson and still stands today.

In 1888, construction began on a new, larger city hall building. Local architect William W. Fife designed the stone structure, which was completed in 10 months. The first floor contained offices and a public library, while the second floor consisted of assembly rooms, council rooms, and courtrooms. This city hall building stood for several decades until it was replaced by the current city and county building.

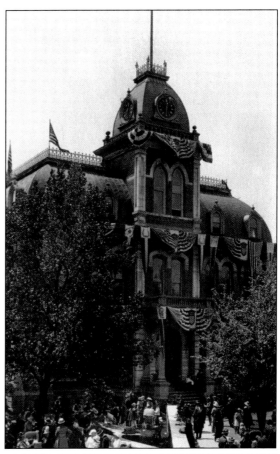

This view looking east on Twenty-fourth Street is from the 1890s. Ogden had suffered economically in the previous decade—as had most of the nation—but the city was progressing, and the frontier town was growing into a thriving transportation center. The opera house pictured so early in Ogden's history is an indication of the importance Ogdenites placed on cultural events.

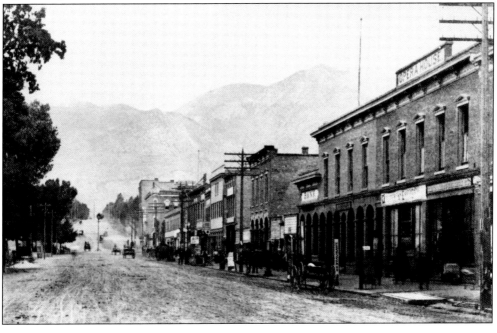

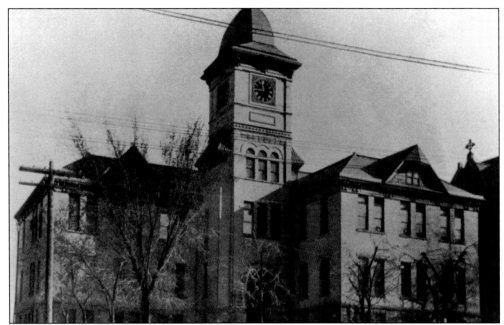

In its earliest days, the Weber County Court met in private homes, schoolhouses, and other buildings. It was not until 1871 that county officials began the process of building a courthouse. The courthouse pictured here, however, was built in 1895 on Twenty-fourth Street between Washington Boulevard and Adams Avenue. It served as a courthouse until 1943 and was demolished in the 1950s.

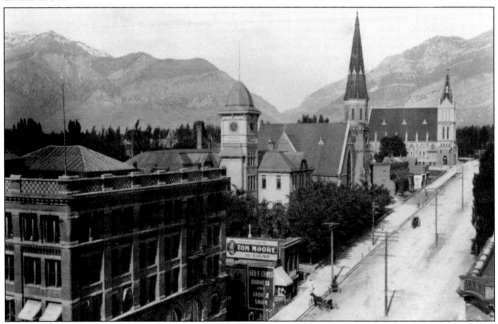

The Methodist church pictured here, directly east of the courthouse, was built in 1890, but Methodist services had been held in Ogden since the 1870s. A Methodist school built on Washington Boulevard was the first Protestant school in the area. In 1925, a new Methodist church was built at Twenty-sixth Street and Jefferson Avenue, and this church building was later demolished.

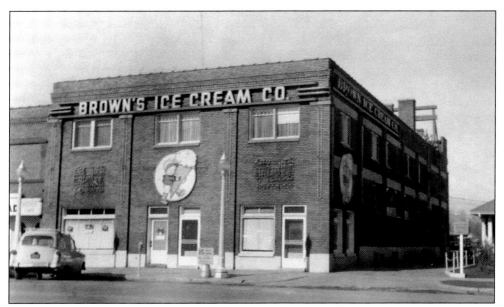

John Brown founded Brown's Ice Cream in 1906. The shop was located at 2551 Grant Avenue. Brown was active in sports, even having a store baseball team in the 1930s. In 1941, his ice cream won top honors in the W.B. Bintz Award for ice-cream manufacturing. Brown passed away in 1944. The shop was purchased by Swift and Company in 1956 for $135,000.

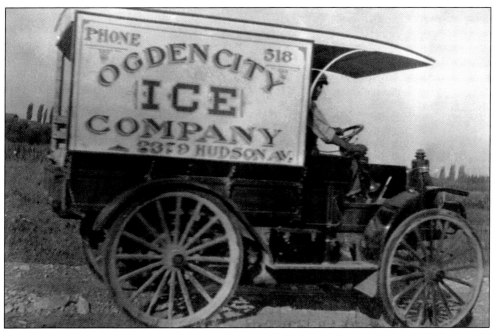

The Ogden City Ice Company was founded in the 1890s at 2379 Hudson Avenue. George Moser, William McClintock, and Henry Harding were on the board of directors. The company manufactured and sold artificial ice and conducted a general cold-storage business. In 1910, the company created an ice pond north of the city, complete with an icehouse.

Founded in 1889, the Ogden Transfer and Storage Company offered packing and moving of safes and heavy hauling from its storage warehouse at 332 Twenty-fourth Street. The company offered the only fireproof warehouse in Ogden during that time. In the 1950s, the warehouse was at 2340 Grant Avenue. In 1958, the company built a 12,000-square-foot warehouse at Twenty-first Street and Wall Avenue.

Early pioneers Nathan A. Tanner and John Watson had both worked for ZCMI for many years before opening their own clothing store in 1906. After changing locations several times, they settled in this site at Twenty-fourth Street and Kiesel Avenue. In 1930, Watson retired, and Tanner died in 1947, but Tanner's son N.R. Tanner continued the business for many years.

In 1855, Peter Boyle came to Ogden and soon began working at furniture making. As he became more successful, he partnered with his son John to build a new facility on Washington Boulevard. They continued selling furniture together until 1881, when Peter passed away. In 1890, John sold the store, but the new owners continued to operate under the Boyle name. In 1907, they moved to this location (below) and continued in business for several decades. John went on to found Boyle's hardware in 1898 with his wife and Joseph and Mary Scowcroft. In 1916, Boyle Hardware moved into a new building (above) designed by Leslie Hodgson.

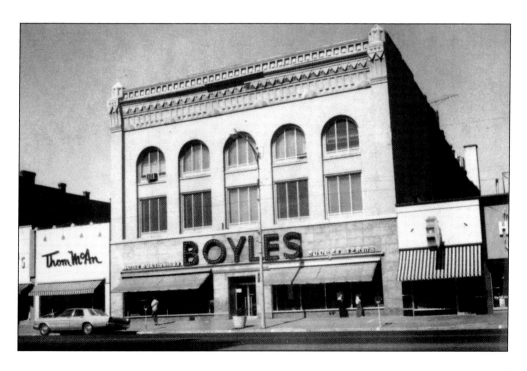

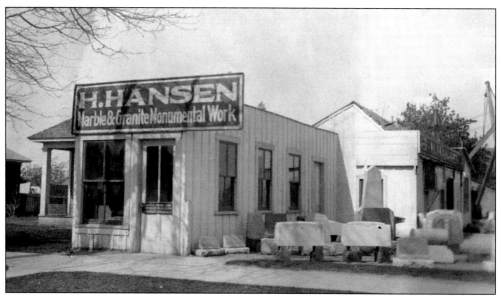

Hartvig Hansen opened his shop at 2003 Jefferson Avenue. He supplied granite and marble monuments and was conveniently located opposite the Ogden City cemetery. He took over the business from the Mitchell brothers in the 1920s. Hansen had a steady business but fell victim to brass thieves for three weeks in a row before they were finally caught.

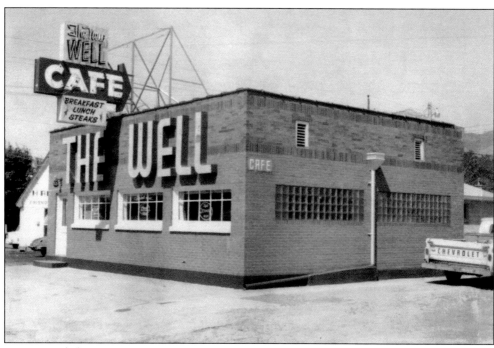

Ernest Beach first opened the Well Cafe in 1939, but ownership of the restaurant soon changed hands to William and Beatrice Cunningham. Advertising their "sizzling steaks and chops," the couple ran the restaurant until 1963, when Richard Burnside took over, changing the name to the New Well Café. The restaurant continued to do business until the late 1970s.

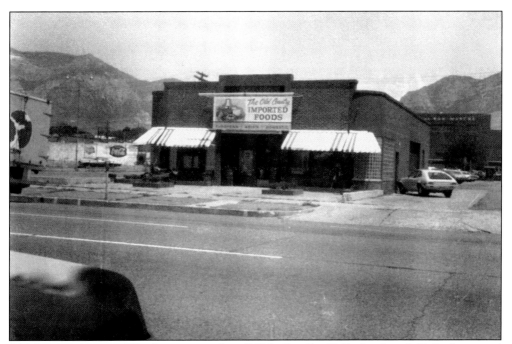

Old Country Imported Foods was opened in 1973 by Bradley H. Bailey, Joseph T. Profaizer, and Dennis R. Kellen. For many years before, this building had been home to the Edward Butters Motor Company and then later served as the Bon Marché storeroom. Old Country Foods focused primarily on wholesale foods and restaurant supply. In 1975, Kellen left the company to become director of the Utah Liquor Control Commission.

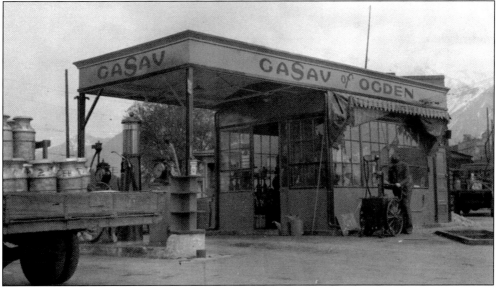

W.T. Giles owned the GaSav of Ogden at 2300 Lincoln Avenue. In 1929, he installed two underground, 1,200-gallon tanks to provide gas to customers. During the 1930s, Ogden customers consumed 540,000 gallons of gas a month. In 1931, the shop expanded to include a double corrugated-iron garage. That same year, GaSav was awarded the contract to provide all the fuel to Ogden City.

The Scowcroft Building was constructed in 1886 at 2325 Wall Avenue. John Scowcroft and Sons offered wholesale goods, including its "Never Rip Overalls," which did not shrink and retained roominess and strength. In 1936, the top floor was used for dressmaking. The building also housed the Blue Pine coffee plant and cannery along with a grocery-packing warehouse.

Proudfit Sporting Goods Company was organized in 1895 at 2327 Grant Avenue. Robert Proudfit was the owner and operator of the pioneer company. The retail store sold sporting equipment along with Edison phonographs in the earlier years. From 1918 to its closure, the store operated more as a wholesale warehouse than a retail store.

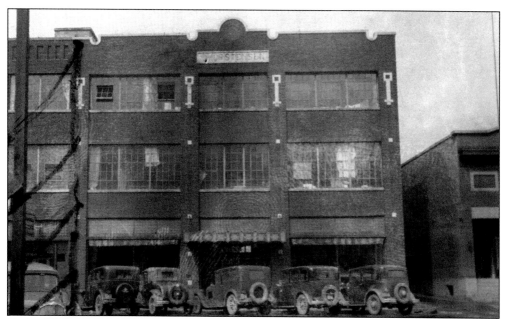

Ogden-Utah Knitting Company was owned and operated by C.H. and George Thorstensen. It first opened in 1906 and provided men's and women's clothing. In 1923, it moved to the shop at 2333 Grant Avenue. In the warehouse, 1,200 suits of knitted garments were made daily. The owners chose the Ogden-Utah name because they wanted everyone to know where Ogden was and to help boost the city and state. The factory remained active until 1962.

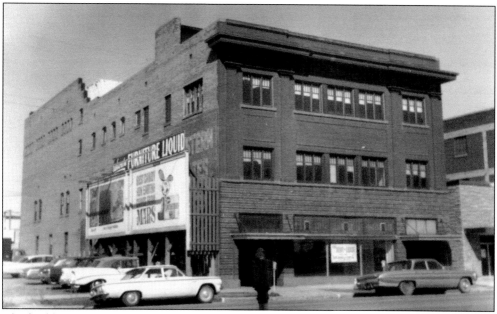

The building at 2351 Grant Avenue has served Ogden in many different purposes. From the 1920s to the 1940s, it was the Knights of Pythias Hall. The Knights of Pythias was a fraternal organization and secret society that counted many prominent Ogden men as members. By the 1950s, the building was occupied by the Ogden City School system. Thomas O. Smith, as superintendent of schools, had his office here.

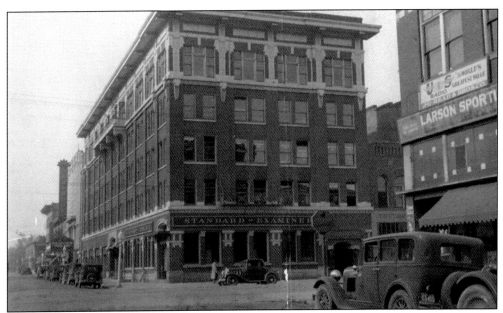

Built in 1914 by Ogden mayor Fred J. Kiesel, the Kiesel Building was home to many businesses, but most importantly, it was home to the Ogden *Standard Examiner* until 1961. The newspaper was founded in 1888 as the *Ogden Standard*, then merged with the *Ogden Examiner* in 1904 to become the paper it is known as today. The Kiesel Building still stands, but it is currently vacant.

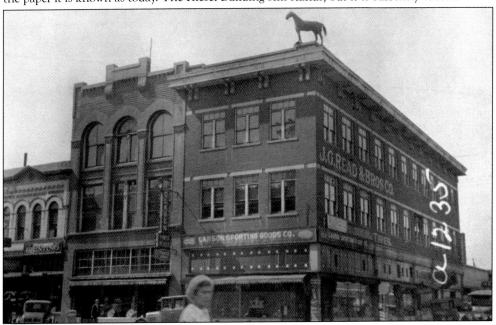

The J.G. Read and Bros. Company, wholesale and retail dealers and manufacturers of leather goods, was organized in 1885. Oscar Read and his brother J.G. started the company. Oscar, the first salesman, covered his territory with a horse and buggy for many years. As transportation changed, the company began selling tires along with harnesses and saddles. The store stood on the corner of Twenty-fourth Street and Kiesel Avenue and was recognized by the black horse that was on the roof.

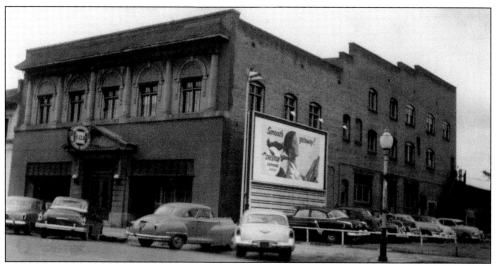

Woodmen of the World, a fraternal benefit society, was founded in 1890 in Omaha, Nebraska. Only a year later, the organization reached Ogden, Utah, when George W. O'Brien was installed as venerable consul for Camp 74. In 1925, the group purchased the Wasatch Athletic Club building, renovating the structure for its lodge. The men continued to use the building until 1969.

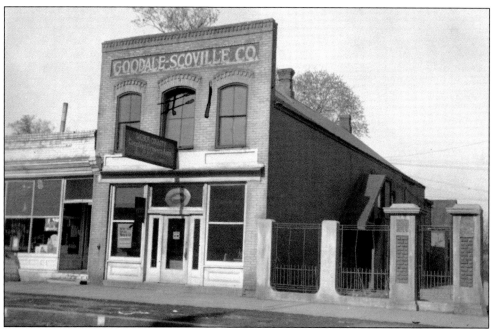

Issac Newton Goodale and Maria Goodale Scoville owned the Goodale-Scoville Company at 2443 Grant Avenue. The auto dealership was known for having some of the first cars in Ogden. It offered the "Grant Six," which were the first Light Six cars below $1,000. In 1917, manager E.F. Malan showed off the cutaway engine that was available in some models.

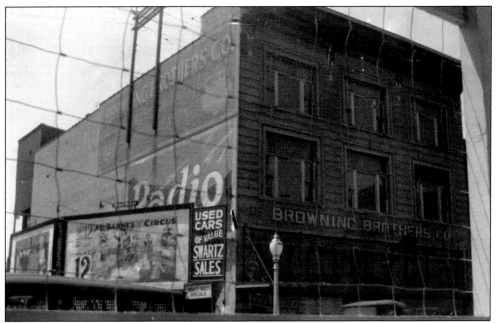

Ogden's largest sporting goods store was owned and run by the Browning brothers. The store opened in the 1890s and ran until the 1930s. In 1893, they petitioned the city to have a streetlight on Hudson Avenue (now Grant) and the middle of Twenty-fourth and Twenty-fifth Streets. This was the location of the store at 2451 Grant Avenue. Thomas Browning managed the Ogden store until 1916. In 1914, the brothers opened a New York office to help move their company into the East Coast.

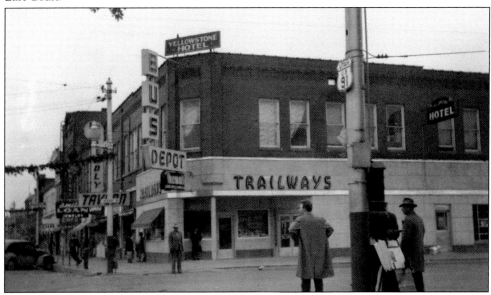

In 1926, the Community Hotel opened at 2485 Grant Avenue with O.O. Corey and George Foley as owners. The majority of the funding for the building came from community members in Ogden. The 63-room hotel's name was changed to Foley-Corey Hotel in 1936. Foley soon left the hotel business to run the Grill Café in Ogden. The name was changed to the Yellowstone Hotel in 1938. In 1949, a bus station was constructed in the lower level of the hotel.

Five

OGDEN EXPANDING SOUTH

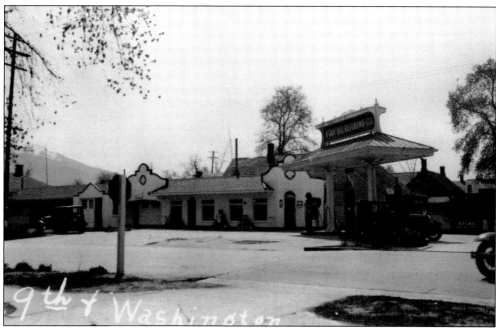

John C. Howard and his associates incorporated the Utah Oil Refining Company and completed construction on their Salt Lake refinery in 1909. In cooperation with the Ogden Gasoline & Oil Company, several service stations were built in the Ogden area. The local newspaper noted that these stations were "attractive and modern" and located "at convenient points in the city." The Utah Oil Refining Company later became part of Amoco.

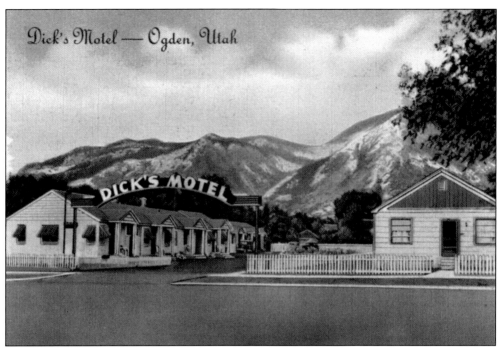

F.F. "Dick" Gunn opened Dick's Motel at 3310 Washington Boulevard in the 1940s. The motel offered 15 deluxe units that were carpeted and had steam heat. Some offered kitchenettes as well. The location of the motel made it a good halfway point between downtown Ogden and Weber College and other points south.

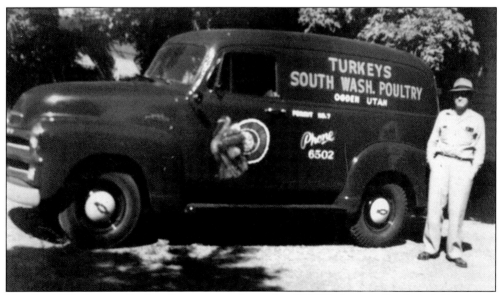

The South Washington Poultry Company was located at 3253 Washington Boulevard. Customers were allowed to select their poultry, which the company would dress for free. The company offered chicken, turkey, and ducks. Jack Platt was the owner of the plant. In 1951, the company had to deal with complaints about the odors that came from the poultry. Platt had suction fans installed on the room that changed the air in the entire plant every three minutes.

Jack White opened the Country Club Barber and Beauty Shop with his wife, LeJeane, at 420 Thirty-ninth Street on July 27, 1954. The couple was very active in community service. In 1959, they worked with the YWCA Y-Teen Club and gave permanents and haircuts in addition to conducting classes in beauty and skin care.

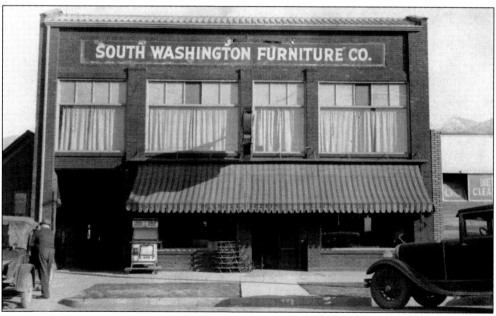

The South Washington Furniture Company was established by H.S. Jensen and A.J. Knight in 1924 in a front room of the residence at 2944 Washington Boulevard. The company began its activities by manufacturing small furniture and toys, which it sold in exchange for used furniture and stores. Over the next 20 years, the business expanded to offer new furniture.

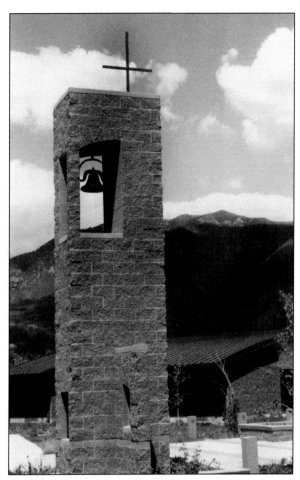

Mount Benedict Monastery at 6000 South 1075 East was started by sisters from St. Joseph. Sisters from St. Benedict's Monastery came to Utah in 1944 at the request of the city to build and operate a hospital. By 1977, the hospital had outgrown its previous location and moved south to Washington Terrace. In 1980, the sisters formed a dependent priory and became their own monastery in 1994. Over the years, the sisters were involved in health care, pastoral ministry, and education. With declining numbers, the sisters decided that they could not continue their monastery. In 2013, they packed up their belongings and records and moved back to Minnesota, leaving a big hole in the community of Ogden.

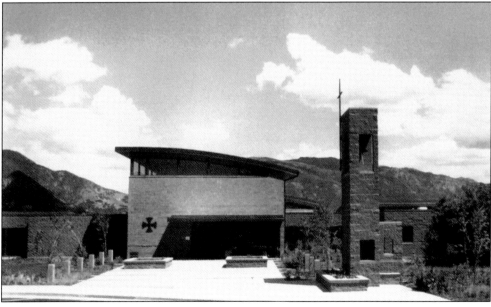

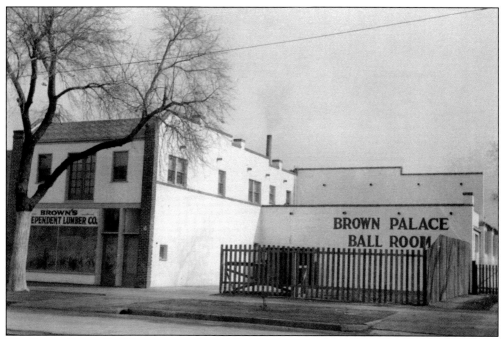

The Brown Palace Ball Room opened in 1932. The dance hall was located at 3122 Washington Boulevard and held dances on Tuesdays, Thursdays, and Saturdays. In 1934, the owners tried to add skating but were declined a license from the city. Shortly after it opened, owner Curt Brown had to agree to not operate during the summer, offer no intermission, and discontinue orchestra practice in order to appease the neighbors.

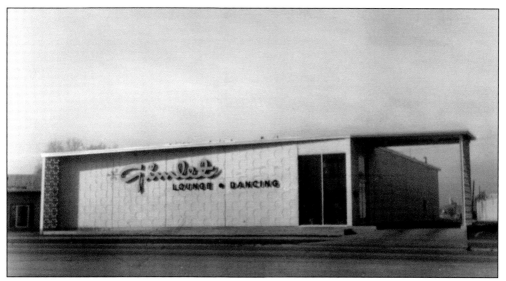

During the 1940s and 1950s, Gimlet Lounge and Dancing was the hot spot for Ogden's nightlife. Operating at 3125 Washington Boulevard, the owners even offered twist lessons during the height of the dance craze. In 1963, the building was sold and converted to a health studio, the Town and Country Athletic Club. The club did not last very long before it closed. Currently, Rita's Bakery operates out of the building.

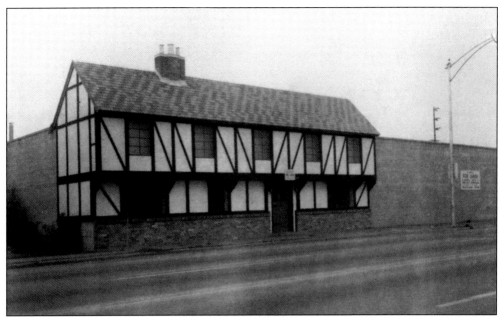

Hurst Lumber called 3131 Wall Avenue home in the 1950s. By 1969, the location housed the Exotica Pet Shoppe. Tom and Shirlee Smith owned the store until the late 1970s. The store was known for exotic animals, including a pet spider monkey and piranhas in fish tanks.

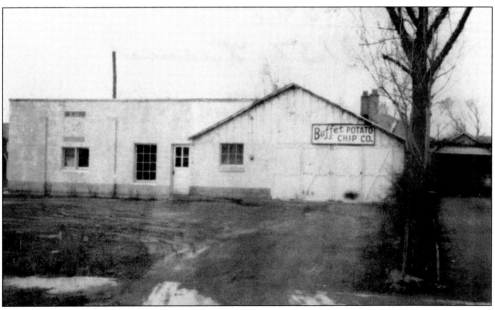

The Buffet Potato Chip Company opened in 1937 at 3151 Reeves Avenue. The original owners were Ellen and Oscar Thomas Jones with their son Archie. They applied for a city permit to open the shop in 1937. The company slogan was "For lunch with a punch." In 1944, the Joneses sold the company to Chester Younger.

Many different shops called 3284 Washington Boulevard home. In 1919, it was the William Weaver grocery store. In the 1930s, it became the Toy Shop. The store manufactured wooden toys and novelty furniture made to order. The owner also repaired dolls and toys. In the 1940s, the building was again a grocery store, Boulevard Grocery.

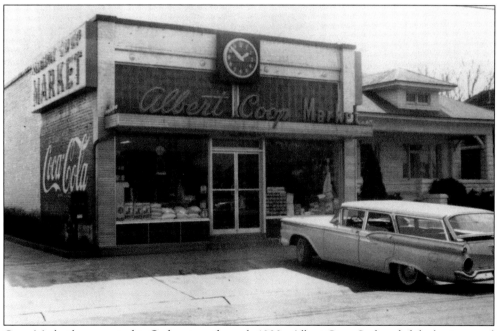

Coop Market has operated in Ogden since the early 1900s. Albert Coop Sr. founded the business and ran the store until 1930, when his son Albert Jr. purchased it. By the 1960s, the Coop family owned and operated several markets in Ogden. Remembered by those who grew up in his neighborhood as friendly to everyone who came into the store, Albert Jr. died of a heart attack in 1966.

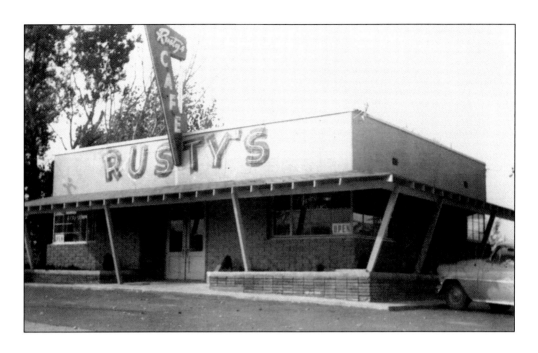

Rusty's Café was owned by Harry and John Dayhuff. Harry was a councilman, and John worked at Hill Air Force Base. They first opened Rusty's at 1873 Washington Boulevard. The drive-in was named after John's daughter Rusty. They were famous for their hot chocolate float and Ironport. The drive-in was so successful that a second location was opened in Riverdale at 3955 Riverdale Road. This Rusty's hosted KLO radio every Friday night in a little shack out front. Rusty's became the south turnaround when teenagers would drag Washington Boulevard. It saw its heyday in the 1960s during the era of drive-ins.

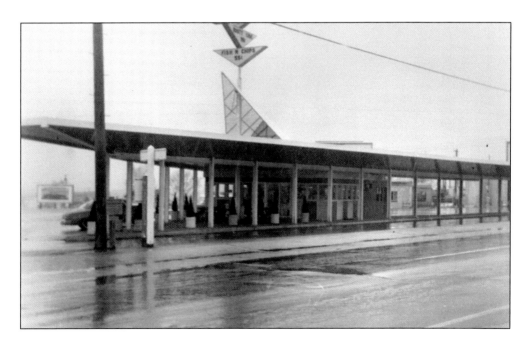

Six

OGDEN EXPANDING NORTH

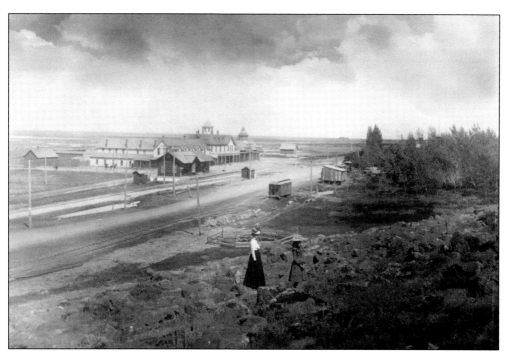

Ranson Slater, a Salt Lake veterinarian, developed a resort in the 1880s around natural hot springs north of Ogden. Rail lines were extended to the resort in the 1890s, making it easier for Ogdenites to travel there. Visitors found not only mineral baths, but also horse racing, saloons, and a hotel.

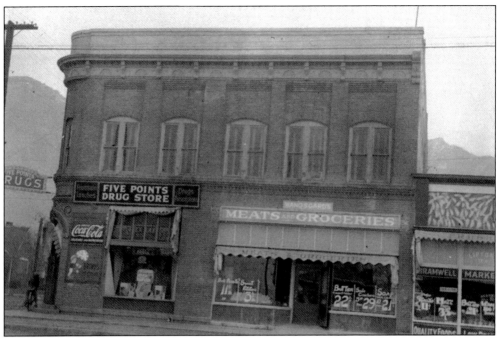

On the southeast corner of Second Street and Five Points stood the Southwell Building, constructed by J.W. Southwell. The bottom floor housed a drugstore, the middle floor housed offices, and the top floor was a popular dance hall. Rass Christopherson was the first to run the new drugstore.

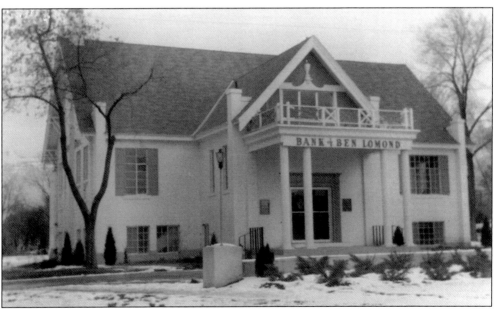

The Bank of Ben Lomond opened June 1957 at 115 North Washington Boulevard, in the growing business community of Five Points. It was the only bank between Twenty-fourth Street and Brigham City. Frank Browning served as president, and Fred Baker, as vice president and secretary. In 1974, the bank merged with the Bank of Utah.

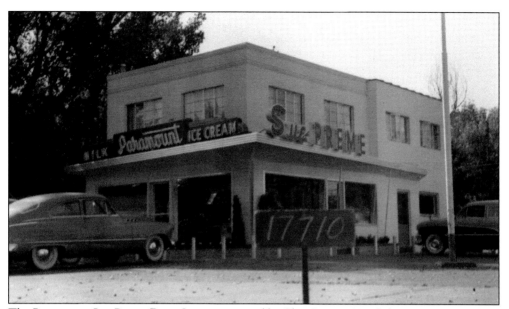

The Paramount Sue-Preme Drive In was managed by Clair Pearce. Her father was Ross Hawkins of the famous diner on Twenty-fifth Street, Ross and Jack's. The drive-in was located at 1111 Washington Boulevard. It was formerly the New Barrel Paramount store before it moved in 1947. The drive-in was known for its ice cream and milk.

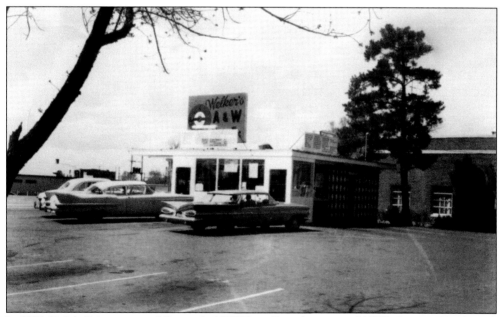

In 1958, Ralph Painter opened Painter's A&W Root Beer drive-in at 344 Washington Boulevard. The restaurant employed between 18 and 25 people and was able to serve 75 cars at a time. For the opening, Painter hired a clown and offered free root beer with all orders. The opening was broadcast over the KLO radio station. By the late 1960s, Mark Welker took over and renamed it Welker's A&W Root Beer drive-in.

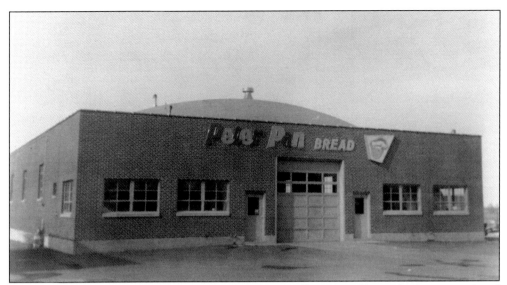

In the 1950s, Peter Pan Bread opened a factory at 1123 Wall Avenue. There, the factory produced Hollywood Bread that was high in protein, vitamins, and minerals but low in calories. In 1959, it introduced the plastic breadbox wrapper to preserve freshness of the bread. In 1963, it added the twist-n-seal packaging to all of its bread products.

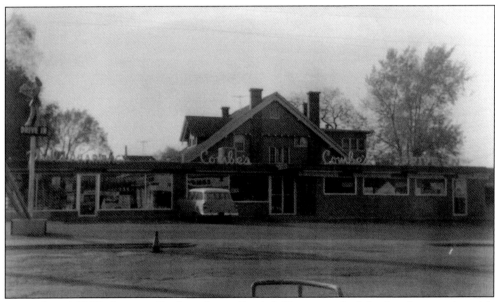

Located at 1207 Washington Boulevard was Combe's Drive-in, which had carhop service with girls on roller skates. Luther and Dorothy Combe opened the restaurant, which was famous for its tots and gravy, pizza burger, cinnamon sundaes with little plastic animals, and Ironport. The spot was a teenage hangout since it was across from Mound Fort and Weber High School. It was the north turnaround for those cruising Washington Boulevard.

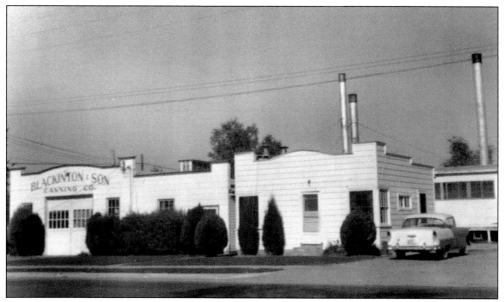

Blackinton & Son Canning Company was founded in the early 1940s by Emmett Reynolds Blackinton. After working as the manager of the Royal Canning Company, he decided to open his own business, running Blackinton & Son out of his home for the first year. In 1941, he moved to this location, where he continued in business until 1972.

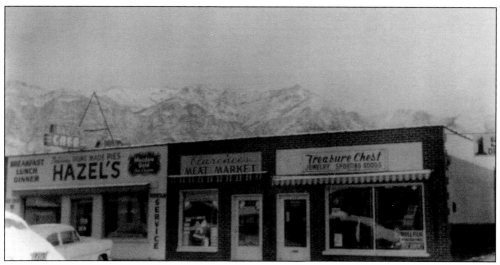

As Ogden continued to grow, businesses branched out from the downtown corridor. At 1512 Washington Boulevard, one of many strip mall–type buildings was established. In 1959, Hazel's Café offered baked-to-order fruit and cream pies. Hazel and John Hobbs also were known for their chicken and beef pies. Just two doors down was the Treasure Chest, which provided sporting goods, jewelry, and archery and fishing supplies.

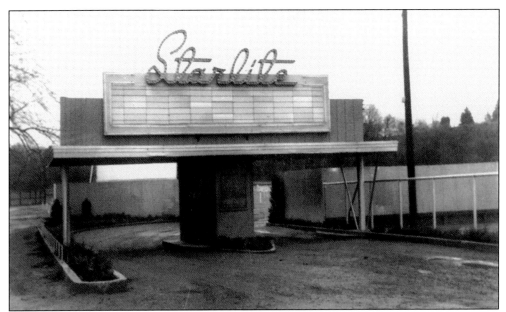

Starlite drive-in movie theater opened in 1949 at 1890 Washington Boulevard. It was billed as Utah's newest and finest drive-in theater. Its opening was not without controversy as the neighbors on Shupe Lane appealed that its license be denied on the grounds that it would worsen already-hazardous traffic conditions at Washington and Park Boulevards. It was closed down in the 1980s.

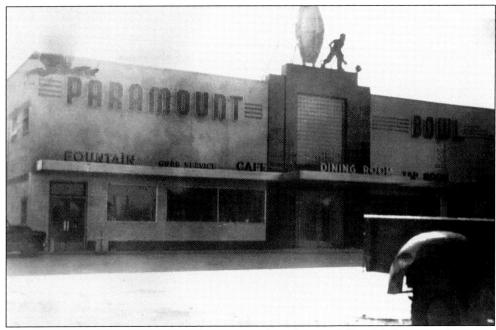

Paramount Bowl opened at 1890 Washington Boulevard in 1946. Ezra M. Peterson, the owner and operator, also owned Paramount Ice Cream. In 1948, he requested that the city allow boys to play pool at the alley along with bowling. In 1956, Paramount had automatic pinsetters installed. Peterson was killed in a drunk-driving accident in 1951.

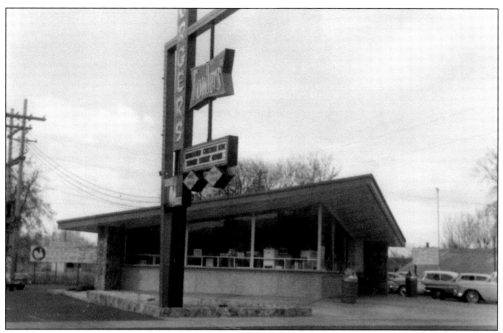

Fowlers opened at 1925 Washington Boulevard on August 4, 1959. It was owned by Norman and Don Fowler. The site originally had space for 50 cars but was expanded to accommodate 104. It was one of the first drive-ins to have no carhops. Instead there were six walk-up windows for customers that provided faster service.

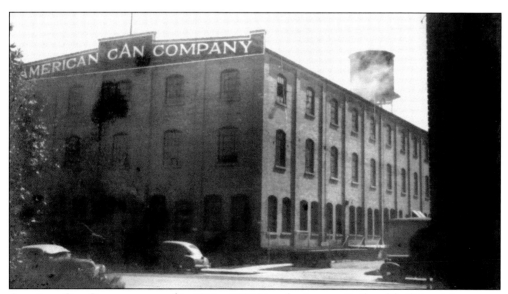

American Can Company opened in 1914 at 2030 Lincoln Avenue. Railroad facilities giving access to other states in the West and the fact that Ogden was the very center of the canning industry in Utah were the two chief reasons why the location was decided upon. The factory employed 100 workers and was the only one between California and Mississippi.

Built in the late 1890s, both of these homes saw many owners in their long histories. Myrtle Douglas moved into 332 Second Street (below) in 1927, shortly after the death of her husband. She raised her six children—five sons and one daughter—in the home while also working at Superior Honey. Four of her sons served in various branches of the military during World War II: Clyde and Donald in the Army, Grant in the Navy, and Richard Keith in the Coast Guard. Myrtle died in 1967. Only eight years later, both homes were torn down to make way for new shopping centers and other businesses.

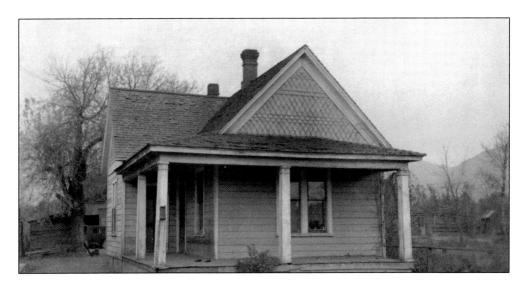

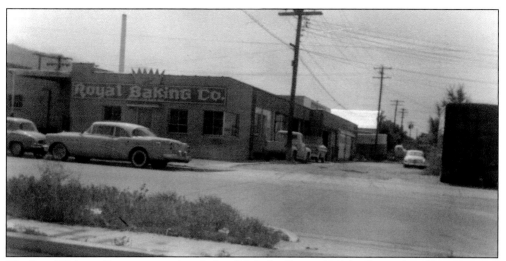

The Royal Baking Company was founded in Salt Lake City in 1893 by George Mueller, a German immigrant who came to Utah in 1890. In 1929, the company expanded to include a plant in Ogden, built at 421 Second Street. The bakery continued its operations for more the four decades.

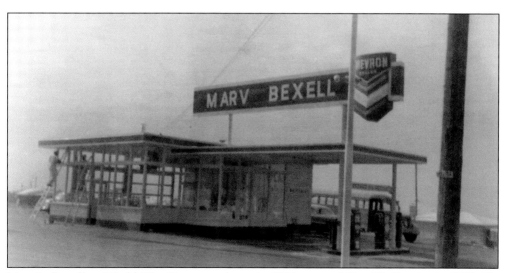

Marvin Bexell, a World War II veteran born in 1924, opened Bexell's Service in 1953. He operated his first service station here on Second Street, and later another on Twentieth Street and Washington Boulevard, until his retirement in 1996. Although Marvin died in 2014, the station on Washington Boulevard still operates under the Bexell name.

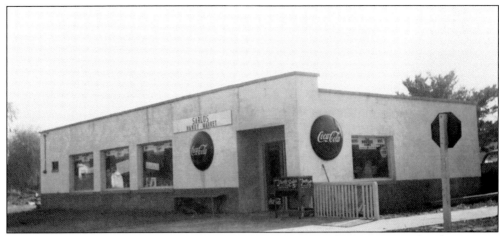

Ralph and Josephine Sarlo were both from Italy. They married in Denver, Colorado, in 1912, and came to Ogden in 1929. Ralph soon opened this grocery store and continued working as a grocer until the 1950s. Ralph was also an avid hunter, once bagging a 35-pound bobcat in the mountains above North Ogden.

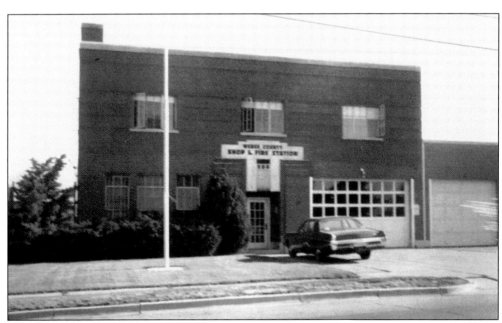

The first, and for many years only, Weber County Fire Department station was built in 1936. The department had 11 full-time men answering calls from Roy to Pleasant View, and even up Ogden Canyon. Heavy competition initially existed between the Weber County and Ogden City Fire Departments, with citizens confused as to which department to contact. Over time, the confusion cleared, and today the Weber Fire District boasts six stations.

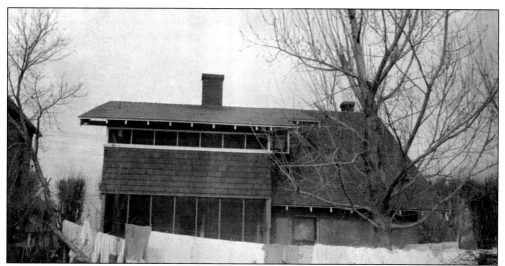

Henry Claude and Dora Barker moved into this home in 1920. Henry worked as a cashier for the Utah Power and Light Company and was the secretary and treasurer for the First Mound Fort Ditch Company. Dora was a member of the First Presbyterian Church Women's Association, the Home Culture Club, and the Daughters of the American Revolution. Henry and Dora died only a few months apart in 1968.

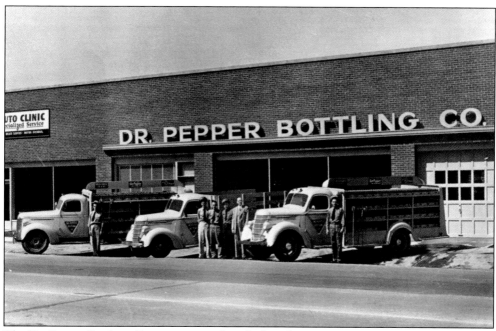

The Dr. Pepper Bottling Company opened its Ogden plant in 1938 at 409 Twenty-sixth Street, under the direction of Stuart and Claire Engle. In the late 1940s, Patrick Healy Jr. took over the plant and moved operations to 1715 Washington Boulevard, pictured here. Dr. Pepper Bottling later moved to Brigham City.

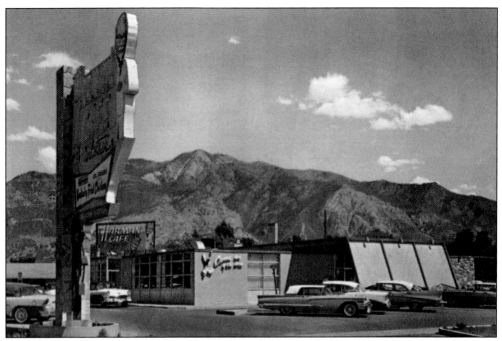

Harman's Millstream Café was located at 1412 Washington Boulevard, right on the millstream. The café was owned and operated by Ogden mayor Harman Peery. The restaurant had four private dining rooms and a seating capacity of 365. The café was noted for its Kentucky fried chicken. The restaurant hosted many banquets and wedding celebrations over the years.

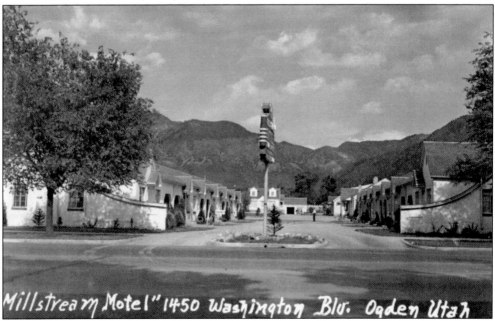

The Millstream Motel was situated at 1450 Washington Boulevard. From 1944 to 1954, Laura Bitton served as manager of the motel. In 1954, it was noted that five cars were lined up in a row outside the motel, all painted with "just married." It turned out that five honeymoon couples spent their first night at the motel and were given neighboring units.

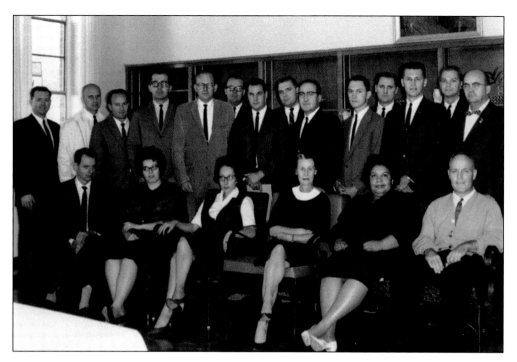

The history of the Utah State Industrial School lasted almost a century. Opening as the Utah Territorial Reform School in October 1889, the school later moved to the site of the old Ogden Military Academy after a fire destroyed the original school. At the new location, the school expanded, building dormitories and other structures. Pictured below is the girls' dormitory known as the Gables. The position of school superintendent was filled by 13 different men, but Claud Pratt served the longest, from 1951 to 1975. Under his leadership, and with the help of faculty and staff, the school was modernized and educational programs improved. The school was closed in 1983, and the site is now home to Ogden-Weber Applied Technology College.

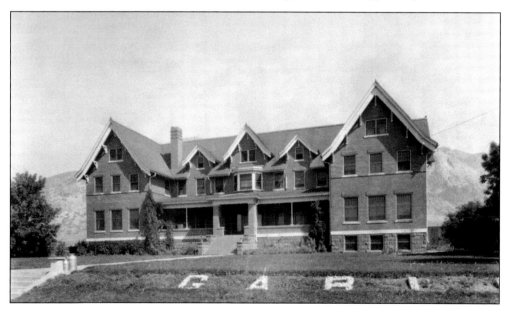

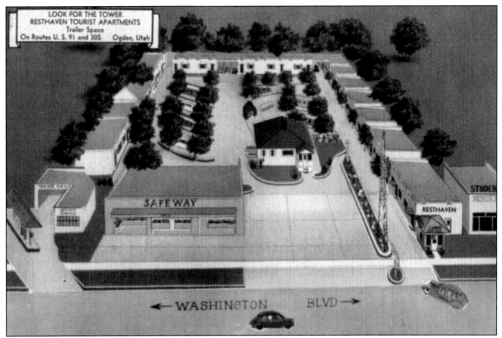

Resthaven Motel was located at 1910 Washington Boulevard. It was just a five-minute walk from the center of the business district. The motto of the motel was "The home camp where strangers are welcome and feel at home." Proximity to the Safeway grocery store and a gasoline station made it a perfect fit for the weary traveler.

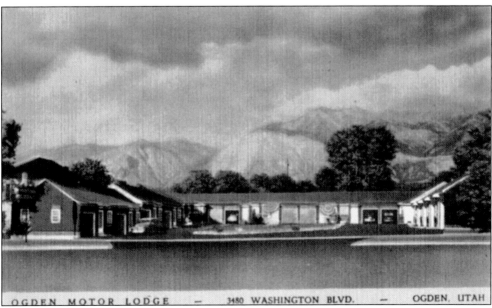

The Ogden Motor Lodge was located at 3480 Washington Boulevard. The rooms were elegantly furnished and offered tiled tubs and showers. Some of the rooms offered kitchens as well. Each room was air-conditioned and came with a locked garage outside for safe car parking.

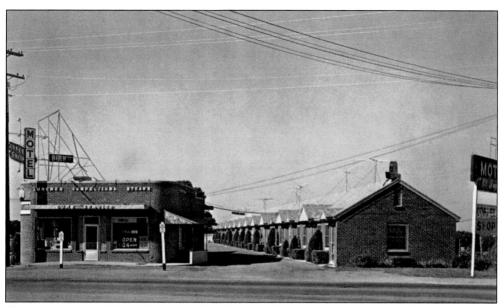

The Mount Lomond Drive Inn opened on Harrisville Road in the late 1940s. The property had several different owners over the years, but Tony Palombi, a realtor, took over the business in 1962 and renamed it the Mount Lomond Motel. He advertised that the motel was the only one in Ogden with both a coffee shop and a lounge. Palombi passed away in 1986, and the motel was later torn down.

By the 1950s, the economy of Ogden had changed from mom-and-pop stores to more national chains. In 1951, there were four Safeway stores located in Ogden: at Twenty-eighth Street, at Twenty-first Street, and at 1508 and 410 Washington Boulevard. In 1955, Safeway was fined by the Justice Department for selling food products below cost and operating retail stores below the cost of doing business in order to take business from local stores.

Miles Jones was a successful businessman and city commissioner. In 1914, he started his own business, the M.L. Jones Coal & Ice Company. In 1915, Jones was elected a city commissioner overseeing the water department and public parks. During his tenure, the Lorin Farr Park was organized. Jones also served on the Ogden City Board of Education and the executive board of the Weber County Red Cross. He died in 1952.

In 1936, William Vandehei married Stella Child. She had grown up in Riverdale, but William was born in Wisconsin. His family moved to Wyoming and then Ogden when he was a child. A graduate of Ogden High School, he ran a gas station on Washington Boulevard and Twelfth Street until he began working for Mountain Fuel Supply Company. In 1952, the Vandeheis built this house not far from the mouth of Ogden Canyon.

Maggie Easterday Higginbotham was born in 1846 in Kentucky. She came to Utah with her parents in 1864 and, one year later, married Simon Higginbotham in Nevada. The couple moved to Ogden in 1866, where they began to raise their family. Eight sons were born before Simon died in 1889. Maggie moved into this house in 1907 and remained here until her death in 1927.

Born in 1866, Abraham "Honest Abe" Ward lived most of his life in Idaho and Wyoming, working as a rancher and tourist guide. His most famous client was George Eastman of the Eastman Kodak Company, whom he led through Montana and Wyoming and on two trips into the Yukon Territory. After his many adventures, Ward settled in Ogden with his wife, Martha, at this home.

James and Blanche Grose moved into this home shortly after their marriage in 1921. James enlisted in the Army during World War I and, after his military service, worked as a machinist for various companies before opening his own machine shop. Blanche worked for several years at Anderson's Seed and Feed, and both were involved with veterans' organizations—James serving as vice president of the Disabled American Veterans.

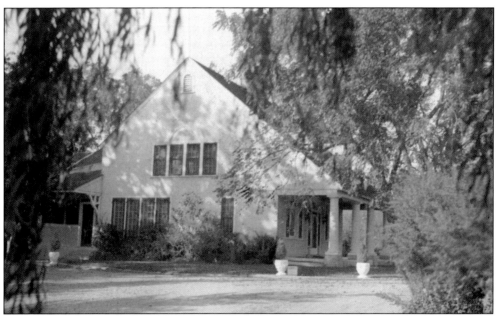

Charles M. Carstensen and his wife, Mary, were longtime residents of Ogden. Their home, near the mouth of Ogden Canyon, was also a fruit farm. Charles worked for many years as a clerk for the Denver & Rio Grande Western Railroad, while Mary ran the White Elephant Tea Room in their home. In 1946, the couple moved to a home a block away but continued their fruit farming.

Seven

Ogden
Expanding East/West

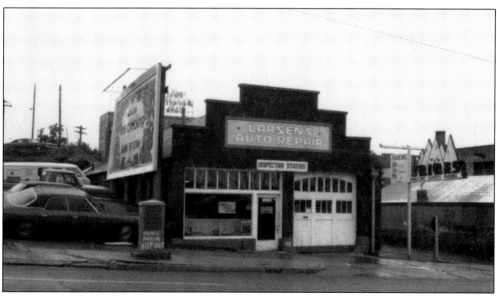

Larsen's Auto Repair was opened by Martin Larsen, a Danish immigrant. A charter member of the Independent Auto Repair Shop Operators Association, he also served as the group's first president. Both he and his wife, Clara, served an LDS mission to his native Denmark. He was also the president of the local Scandinavian association. Larsen died in 1959 at the age of 79.

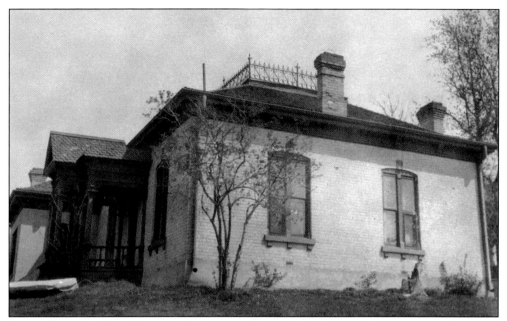

Originally a single-family home, this house on Twenty-first Street was later converted into two apartments. In the early 1940s, Joseph and Mary Broadbent and Howard and Alma Etterlein moved into the apartments. Both Joseph and Howard worked for the Southern Pacific Railroad Company, although Howard would later work for the Ogden Arsenal. Both families remained in the home for more than 50 years.

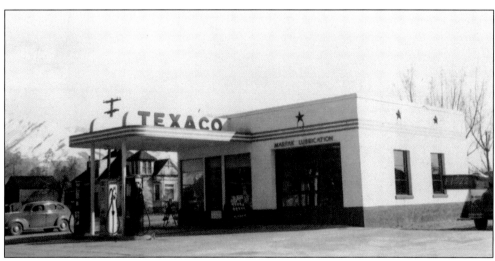

Built in 1940, this service station was first known as Berry's Service and was operated by Walter S. Berryessa. The next year, George Wilson took over the station, calling it George's Texaco Service. Property ownership changed many times, but it remained a service station until the mid-1960s. After standing vacant for several years, the building was torn down in May 1975.

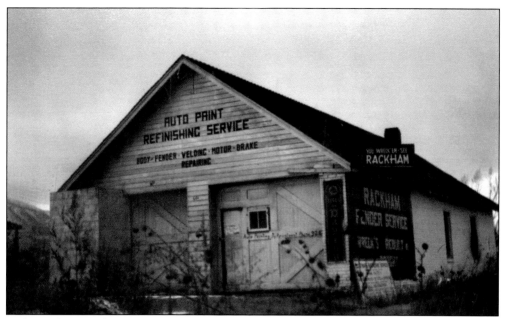

Built on the site of Ogden's former brickyards, Lawrence Rackham's auto body shop opened in the 1940s. But what had once been an industrial area was soon rezoned for residential purposes. Newspapers reported complaints from neighbors who wanted Rackham's business moved. Despite complaints, the property continued as an auto shop until 2013.

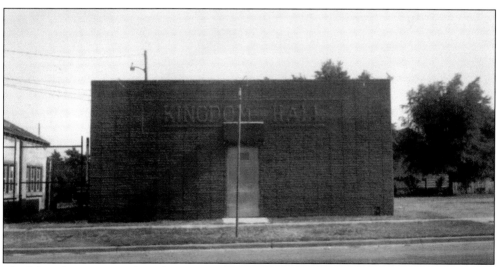

The Jehovah's Witnesses have been in Weber County since 1909, meeting in various buildings throughout their history here. In 1954, the group dedicated this new building, which was their home for about a decade. About 125 delegates from Ogden attended assemblies in Los Angeles and Vancouver in 1955, with E.S. Griffith as presiding minister.

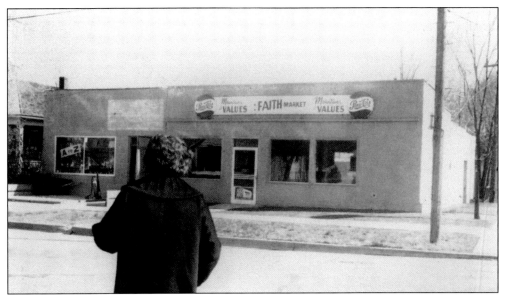

During the 1960s, the Church of God in Christ met in this building under the leadership of Pastor R.L. Harris. He later opened the Faith Market, as well as several other grocery stores in Ogden. Known as a civil rights activist, Harris organized peace marches in Utah and around the nation. In 1976, he became the first African American elected to the Utah State Legislature. He passed away in 2005.

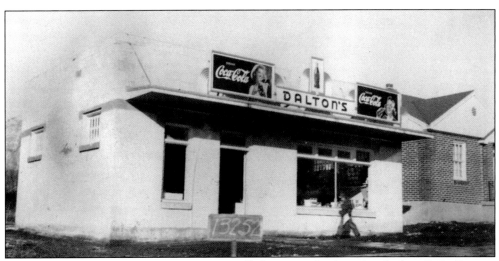

George F. Dalton opened his grocery store just off of Harrison Boulevard in the late 1940s. Born in 1879 in Circleville, Utah, Dalton came to Ogden in 1914. He learned the grocery business in the employ of J.S. Daniels. Although he was only at this location for a short time, Dalton continued to operate his grocery business until his death in 1960.

In 1940, Ogden mayor Harmon Peery purchased the site of Lorin Farr's original gristmill and opened Harm's Old Mill Inn. Known as the "largest Western style dance hall and cabaret in the state of Utah," the inn is still remembered fondly by Ogden's citizens. The inn and several nearby cabins like the one pictured here were later torn down, and the property was converted into condominiums.

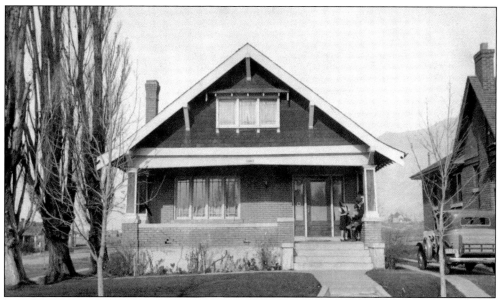

In 1914, William M. McKay and his wife, Calleen, moved into this home on Ogden's east bench. William, the nephew of LDS Church president David O. McKay, later moved his family to Chicago to attend medical school. In 1926, he returned to Ogden and practicing medicine with another uncle, Dr. Joseph R. Morrell. In the late 1930s, he began working for the state board of health, and the family moved to Salt Lake City.

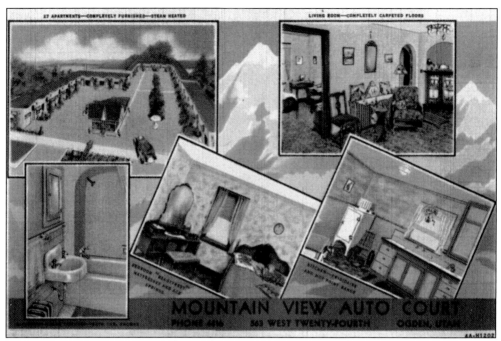

Mountain View Auto Court was located at 563 West Twenty-fourth Street. The motel provided 27 apartments, all with steam heat. Each apartment had a combination shower and bath and was fully furnished. The location next to the stockyards made it the choice of many ranchers doing business there.

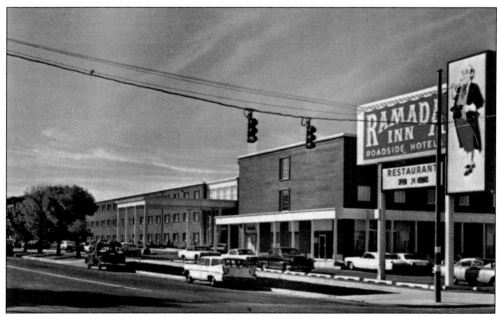

The Ramada Inn was found on the corner of Twenty-fourth Street and Adams Avenue. During the 1960s, it was Ogden's newest, largest, and finest hotel. The inn had 150 rooms and a heated pool. The guests had access to the Golden Spike Lounge and Highlander Restaurant. The inn was built on part of the former real estate holdings of the D.H. Peery estate.

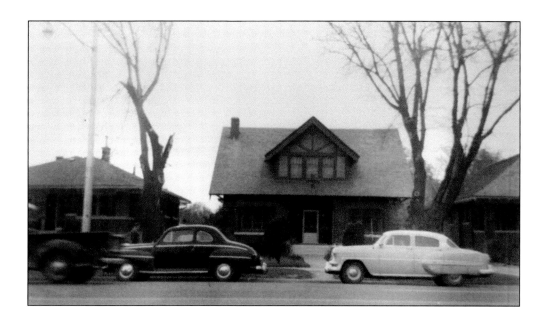

The Red Cross has been active in Ogden since the early 1900s. Many of Ogden's most influential people have served on the board of this important chapter. In 1952, the Red Cross home was located at 1951 Washington Boulevard. It offered home nursing classes to residents of Ogden with courses in care of the sick and mother and baby and family health. The classes were designed to give the maximum of practical experience and a wealth of information in the shortest time possible. Pictured below are two unidentified women who worked for the Red Cross during the 1950s.

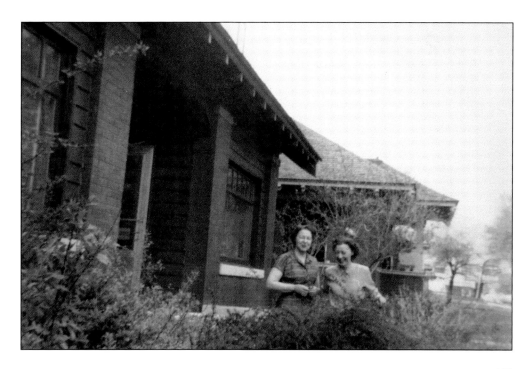

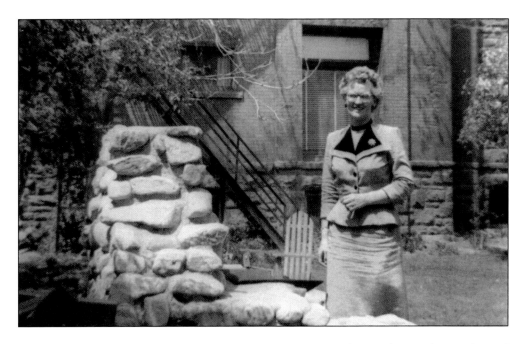

The headquarters of the Young Women's Christian Association (YWCA) in Ogden was located at 505 Twenty-seventh Street during the 1950s. The agency was sponsored by the American Association of University Women. The headquarters once served as the home of John Moses Browning, a prominent gunsmith. Seen in the photograph above is Virginia Dove, who served as executive director of YWCA. The group was a youth-serving organization of young girls and young married women. It often encouraged men and women of all ages to turn to the YWCA for fun, new friends, interesting pastimes, and hobbies. The group offered classes on a variety of subjects.

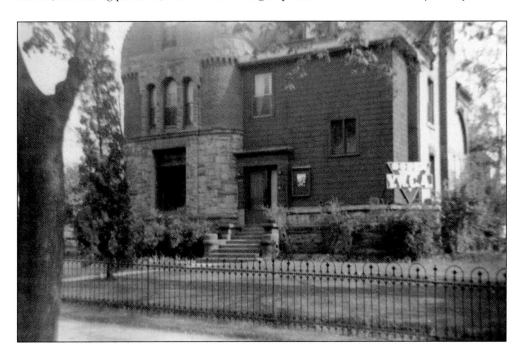

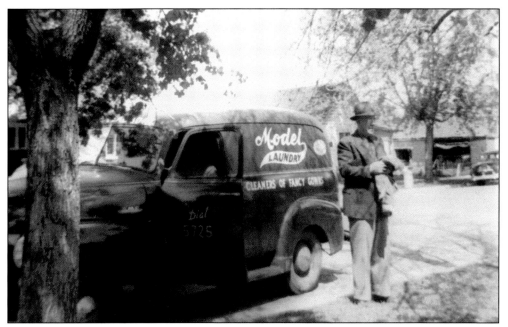

Model Laundry was located at 2153 Pingree Avenue. George Bateman served as manager of the shop that advertised itself as "Cleaners of Fancy Gowns." In 1932, the store was cleaning men's suits and women's coats and dresses for 40¢ with free delivery; lace curtains were 25¢, and fancy curtains, 5¢.

Sylvia and Nicholas Greelman opened their grocery store at 3290 Wall Avenue in 1926. Nichols emigrated from Greece in 1914 and changed his last name from Psihoyious to Greelman. The store started as a confectionery and then was turned into a grocery store. The Greelmans owned the store until 1960. In 1968, the Kansas chain of self-service shoe stores opened Pay-Less Shoes.

The Weber Stake Academy was founded in 1889 by the LDS Church, but in 1933, the school was transferred to the State of Utah, becoming a junior college. The first campus was built downtown, above Adams Avenue, between Twenty-fourth and Twenty-fifth Streets. In 1951, the college moved to its present location on Harrison Boulevard. The first buildings constructed were the four pictured below, where all of the college's classes were held for many years. In 2011, Weber State began demolition on these buildings to make way for larger structures. Also built early on was the school's stadium, although today it looks much different. Today, the Stewart Stadium seats 17,500 fans and houses the Athletic Department's offices.

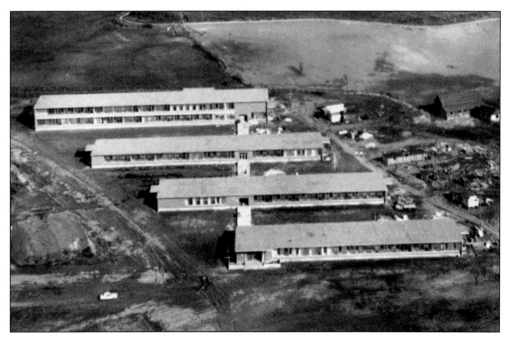

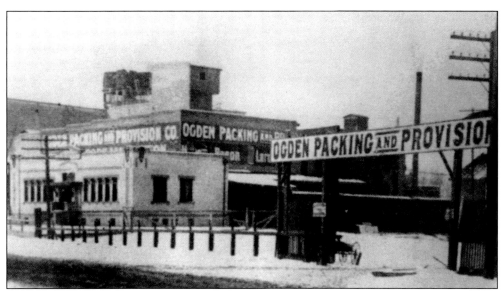

In 1893, F.E. Schlageter founded the Ogden Packing Company, which shipped meat throughout the West. In 1906, the company was reorganized as the Ogden Packing and Provision Company, with Schlageter as the president, Lars Hansen as vice president, Simon Jensen as secretary, and James Pingree as treasurer. It soon began construction on this larger plant, estimating its capacity at 700 cattle, 4,000 sheep, and 5,000 hogs per week.

The Hermitage Hotel was built by William Wilson in the Ogden Canyon. The inn was built of native pine, maple, and oak and opened in 1905. There were 25 rooms to start, and another 16 were added on the second floor. The hotel was a popular place to visit, not only with tourists, but also among Ogdenites looking to escape into the mountains. The resort stood until 1939, when it was destroyed by fire.

Obtaining enough water to irrigate local farms was one of the first concerns of Ogden's pioneers. East Canyon, carved by the Weber River, sits south of Ogden, while the Ogden River winds through Ogden Canyon to the north. As Ogden and the surrounding communities grew, it would take the damming of both rivers to provide enough irrigation. The first East Canyon Dam (left) was a simple earthern dam built in 1896. It was replaced in 1913 with a concrete dam. Pineview Dam (below) was not constructed until 1934, although there was some minor damming of the Ogden River before that. Ogden Valley's famed artesian wells, which were buried under the Pineview Reservoir, were capped underground, and the water was piped through the canyon into the city. This artesian water is still a source of Ogden's culinary water.

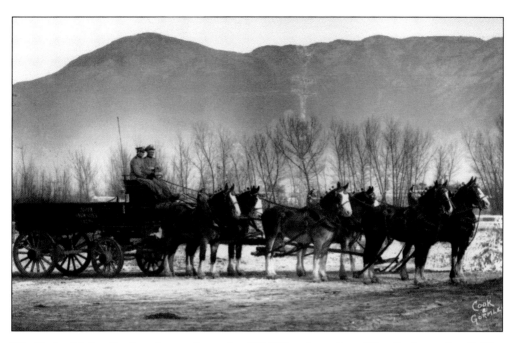

The Ogden Union Stockyards were located at 550 Wilson Lane (now West Exchange Road). The construction of the stockyards by a group of Ogden businessmen began in 1916, with the addition of the annual Ogden Livestock Show in 1919. The stockyards were the unloading center for cattle, sheep, and pigs destined for the large packing plant on the east bank of the Weber River. The facilities included open and covered pens, loading chutes, barns, sheds, scale houses, auction rings, and a livestock-exchange building. Pictured below is one of the of many meat inspectors who frequented the packing plant to ensure the quality of products being made.

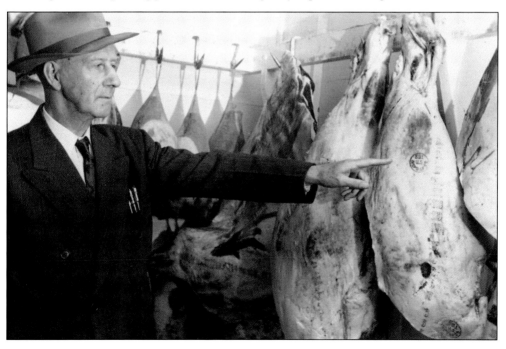

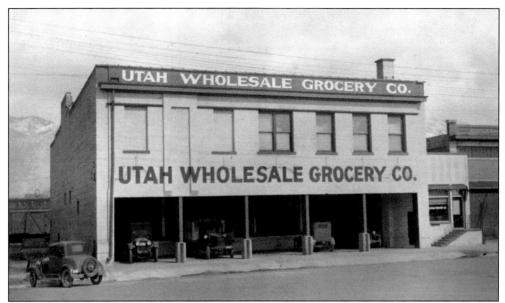

J.S. Campbell bought Utah Wholesale Grocery at 2364 Wall Avenue. In 1923, it employed 18 people and did a yearly business of $800,000. The company employed traveling salesmen who offered proximity to raw materials and ease of shipment with the central rail location. In 1927, the business merged with Ogden Wholesale Grocery. In 1928, it included a one-year lease with Pacific Coast Canners.

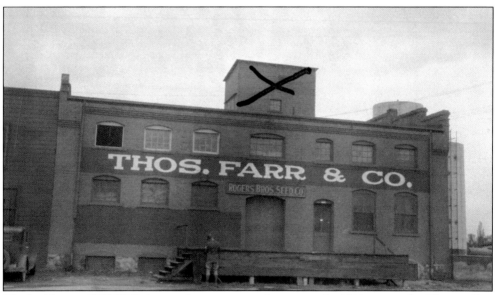

The building at 2255 Wall Avenue has seen many businesses. In 1918, it was the Thomas Farr and Company warehouse. During the war years, the company bought flour from citizens and gave it to the government for war purposes. In 1930, Rogers Brothers Seed Company took over the warehouse and specialized in Utah beans. By 1938, the building had become home to the Utah Wool and Hide Company, handling muskrat, mink, and raccoon hides.

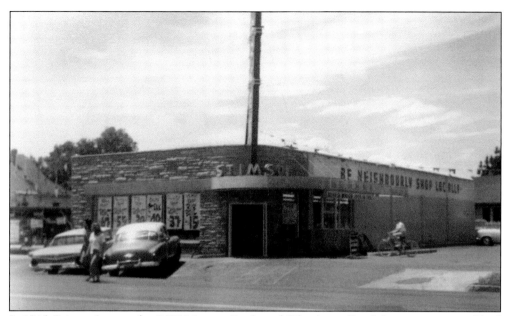

In 1945, Stimson's opened at 2605 Monroe Boulevard. The shop offered the convenience of food shopping at a central location. The business had three drive-through windows and offered over 500 items. The products and services included beef, gasoline, laundry and dry cleaning, fried chicken, and dairy. It was one of the few shops that had no closing hours.

J.M. Patone first came to Ogden in 1904 and worked in theaters, including the Utahana. In 1906, he opened a small candy store and slowly began to add violins and pianos. The Pantone Music Company at 2874 Kiesel Avenue was the place to rent or purchase musical instruments. Patone retired in 1927, but he reopened the store to provide violin instruction.

In 1888, Isaac Pierce founded the Utah Canning Company at 2915 Pacific Avenue. It was Utah's oldest cannery and had a reputation for quality, service, and fair dealing. The company was known for its pork and beans, hominy, sauerkraut, tomato soup, Worcestershire sauce, and tomato ketchup. In 1918, the company had grown so large that three additions were made to the building to increase storage space, add labeling and packing, and provide spaces for offices.

Donald P. Atkinson and his wife, Marjorie, built their home on Ogden's east bench in the mid-1950s. Married in 1946, Donald worked as a boiler fireman and later as an engineer at Defense Depot Ogden. They lived in the home until 1970. Marjorie passed away in 1982, and Donald in 2004.

In 1913, Joe Alkema and a partner started selling home-baked goods in a horse and buggy. They started slowly, but in 1935, Joe's Home Bakery moved into new facilities on Ogden's west side. Joe retired in 1944, but his son Lloyd took over the business. The company boasted that all the flour used in their products was purchased locally. Its goods were sold from Ogden to Cedar City.

As Ogden expanded, the need for convenience stores came into the neighborhoods. At 878 Polk, a 7-Eleven market was opened with John Hicks as manager. In the 1970s, the 7-Eleven stores were the only shops open in Utah on Sundays, but they could only sell certain items. The law at the time said that food could only be sold for consumption by tourists and not for home consumption. The stores encouraged patrons to vote and change the law.

In 1938, R.J. Wight opened a feed mill at 1999 Wall Avenue. Along with providing feed for farm animals, he grew his own turkeys and had a processing plant. In 1955, the plant caught fire, and the entire building and contents were destroyed, with a damage estimate of $250,000. Only the exterior cement walls survived the inferno. Wight was lucky that the turkey-processing plant was not burned, only the feed warehouse.

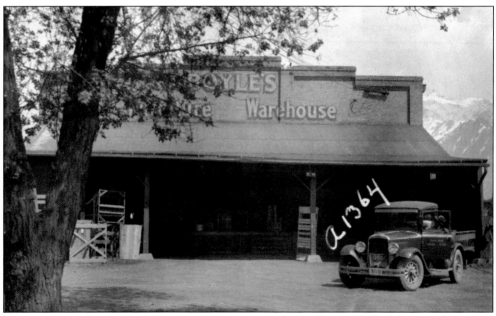

The warehouse for the Boyle Furniture Company was located at 2250 Wall Avenue. It was the largest in the state of Utah during the 1920s. Proximity to the railroad allowed Boyle to ship furniture to all parts of the West and beyond. The warehouse being close to the showrooms allowed for the company to add more furniture so customers could peruse the many different types available.

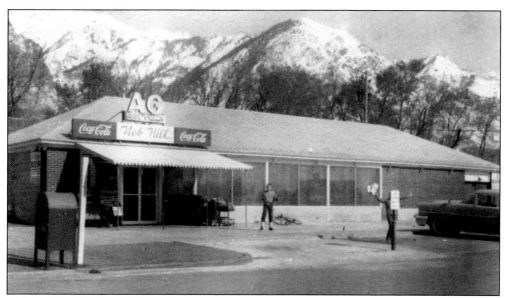

As housing increased on the east bench of Ogden, convenience was taken into account. Herman Hart opened and operated the Nob Hill Market at 2304 Polk Avenue. The market provided for the grocery needs of the locals. In 1957, Hart died of a heart attack while hunting ducks in West Warren.

The Troc Lounge and Grill opened in 1967 at 350 Twenty-seventh Street. Wayne and Marian Garfield were the owners, and they worked very hard to treat everyone the same way, whether he or she was a cop, a lawyer, a construction worker, or a person who lived on the street in need of a hot meal. The grill had some of the best burgers available in Ogden and was famous for its stuffed burgers and gravy on fries.

A.W. Bartlett used 455 Twenty-fifth Street for his car dealership. In those days, a few new cars were put on display in the windows, and then the customer ordered the car. After the car dealership closed, Miller Floral opened a retail shop in the corner of the building. This operated until the 1970s, when it was turned into a Mexican restaurant. Señor Frog's served patrons until the 1990s, when it was closed down.

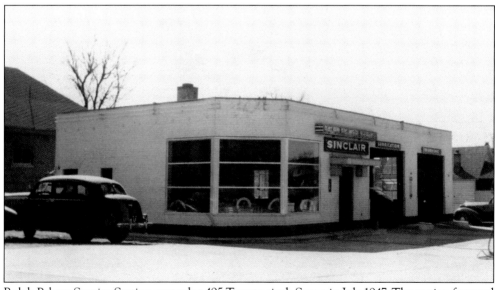

Ralph Palmer Service Station opened at 495 Twenty-sixth Street in July 1947. The station featured Sinclair gasoline and oil. Palmer had worked in the industry since 1932 and owned his own station since 1935. He was joined by Dail Rose as the mechanic and James Steele as the lubrication specialist. The motto of the station was "If we can't do it, we'll get it done for you!"

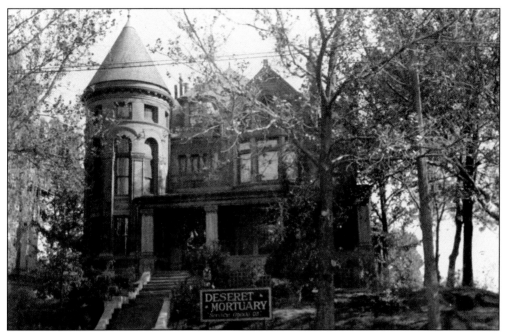

In 1940, Deseret Mortuary Company opened at 533 Twenty-sixth Street. The business was in the former home of John Scowcroft. Billed as the West's finest mortuary, the company stated that nothing was too good for the people of Ogden. The chapel could seat 650 people and provide for all the needs of the grieving family. The mortuary was known for the Rose Parlor and Rainbow Parlor viewing rooms.

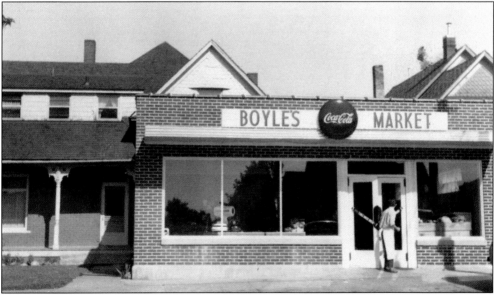

Clair Boyle opened Boyle's Market at 540 Twenty-eighth Street. He offered a complete line of staple and fancy groceries. In 1948, the store was remodeled and offered self-service along with free delivery. Mark Bower, manager, advocated that food stamps allowed customers, especially the elderly, to buy more things and eat better.

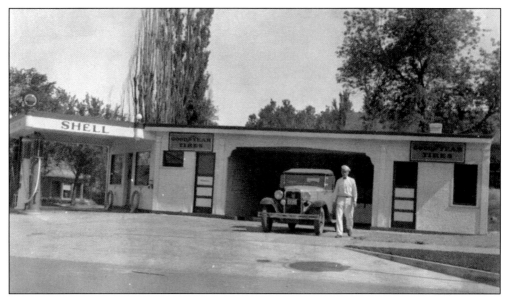

Following the introduction of cars, service stations started to appear throughout Ogden. Robin's Bench Service opened at 600 Twenty-seventh Street in 1939. It became Russ and Jack Service Station, owned by Russell Weber and Jack Horner. In 1941, Russell was drafted into the Coast Guard, where he served for two years in Hawaii. Jack took over the business until his death in 1959.

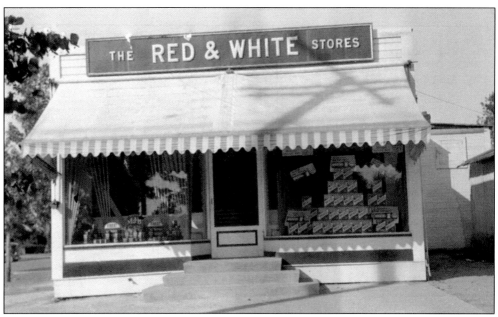

Red & White Stores were prevalent throughout the United States. In Ogden, one opened at 800 Twenty-eighth Street. The stores ran on the practice of buying local food and supporting local businesses. Each store was owned and operated by someone who had affiliated himself with a number of similar independent stores in the city and was serviced by a local wholesale grocer.

Eight

LOCAL EVENTS

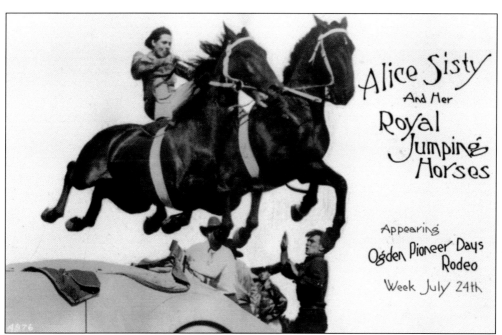

The Ogden Pioneer Days brought in some and artists from across the country to entertain the crowds at the stadium. In the 1930s, Alice Sisty was known for being the only woman who could jump two horses Roman style over an automobile. She was featured in Ogden for several years. She began her career as a schoolteacher but turned into a world-champion cowgirl.

In 1956, Dell Adams was known for his museum of Western history, which filled a large room in his house. The collection included pioneer items, Civil War artifacts, and a number of items related to the ill-fated Donner Party. He had also collected a snowshoe used by Pony Express horses to get over the Donner Pass snows. Along the walls were mounted heads of trophies shot by Adams in his hunting trips, along with a large number of old firearms. Adams started collecting when he was a little boy and became fascinated by an old knife-and-fork set. His wife, Sarah (below), was also involved in the collecting of historical items.

Born in New York, Linda Irwin came to Utah in 1891. She worked as a schoolteacher for most of her life, retiring in 1929. When she came to Utah, she brought with her a number of items that had belonged to her family when they lived in New York in the 1700s. She is pictured here with her collection, which she shared with the local chapter of the Daughters of the American Revolution.

Living in Ogden's early days required constant work, but sports and other forms of recreation provided the occasional—and much-needed—distraction from the routine of everyday life. Ogden Canyon was a great place for hikers, picnickers, and bicyclists alike. Although the bicycles look a little different, Ogdenites continue to enjoy cycling through the mountains today.

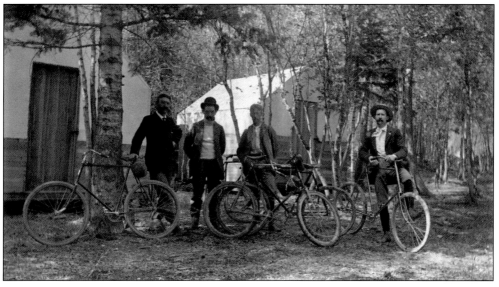

Part of Ogden's Pioneer Days celebrations has been the Pioneer Day parade. In 1938, the celebration began on July 19 with a parade of floats and people. The observance was dedicated to the Mormon pioneers. The street parades depicted the progress that was made during the 91 years since pioneers arrived in the area. Comic character Dinny the Dinosaur was featured in the celebration.

In 1936, the Pioneer Days celebrations included parades over three mornings from Wednesday to Friday. Businesses and organizations from around town all created floats to show off down Washington Boulevard. Pictured here are some Ogden men re-creating the drive across the plains for the Mormon pioneers. The carts are being pulled by a burro and a cow. Mayor Harman Peery is featured standing in the front.

As the Pioneer Days tradition continued, the parades became more about the advances of transportation and showcasing the youth of Ogden. In the photograph above, a car drives down Washington Boulevard in the 1956 parade. One can see the people lined up—even on roofs and in store windows—to view the parade. The photograph below shows three young men as they march past the Egyptian Theater on Washington Boulevard. Crowds line the street but seem more dispersed than in the previous image. The tradition of the grand parade continues to this day, but with more emphasis on the week of rodeo activities.

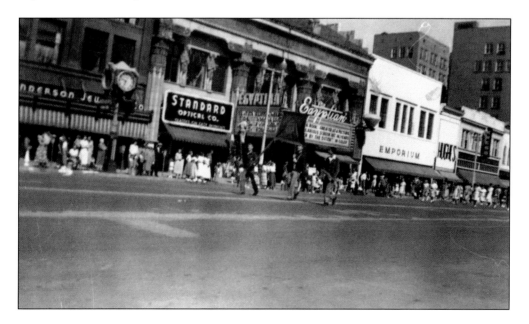

Ogden City sponsored a complete recreation program for all the children during the year. There were seven play areas and fun to be had by all. To start the summer off, one of the ice-cream factories gave a huge, seven-foot-tall cone full of ice cream to the children. From the massive ice cream, each child was given a smaller cone.

Ogden's first children's parades were organized to celebrate the schools that the community was so proud of. Children would form bands, make banners, and show off their school spirit in a parade that wound through the downtown area. Later parades, such as this one from 1952, were a part of the town's parks and recreation program.

Every year on July 30, there was a Huck Finn Day, with prizes given for the different phases of fishing. Many of the fish that were added to the streams were given to the Ogden Recreation Department by the Utah Fish and Game Department. Lorin Farr Park was loaded with legal-size trout in the Ogden River at the park bridge. Watchers lined up along the riverbank to see the fish being let out of the nets and finding their way downstream to the waiting young fishermen.

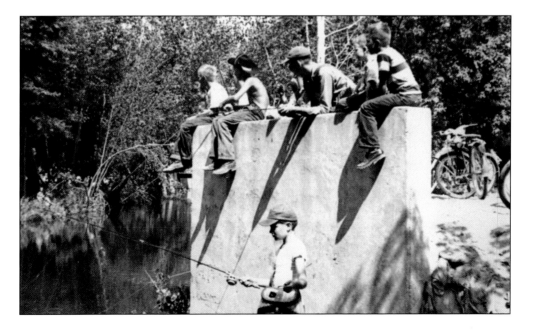